Remembering

FAIRFAX COUNTY

Virginia

Remembering
FAIRFAX COUNTY
Virginia

KARL REINER

Charleston · London

THE
History
PRESS

Published by The History Press
Charleston, SC 29403
www.historypress.net

Front Cover:
Photographs courtesy of the Library of Congress

First published 2006
Second printing 2008

Manufactured in the United Kingdom

978.1.59629.096.9

Library of Congress Cataloging-in-Publication Data

Reiner, Karl.
 Remembering Fairfax County, Virginia / Karl Reiner.
 p. cm.
 ISBN 1-59629-096-X (alk. paper)
 1. Fairfax County (Va.)--History, Local. 2. Fairfax County
(Va.)--History, Military. 3. Virginia--History--Civil War, 1861-1865. I.
Title.
 F232.F2R45 2005
 975.5'291--dc22
 2006006868

Notice: The information in this book is true and complete to the best of our knowledge. It is offered without guarantee on the part of the author or The History Press. The author and The History Press disclaim all liability in connection with the use of this book.

CONTENTS

Introduction

The passage of time has brought with it vast alterations to the landscape of Northern Virginia. What was once a sleepy rural area dotted with a few small villages has changed into suburbs that are now home to thousands of people. Houses, shopping centers and highways cover much of the very same ground on which previous generations sacrificed and endured, thereby participating in the making of history. Between the years 1995 and 2005, Karl Reiner wrote articles about regional long-ago events for a newspaper and a historical journal. Although they are now part of the dusty past, the impact of these events on America lingers to this day because they affected our technical progress, the basis of our political system and the development of military strategy. Many of the historic happenings occurring on the same land on which we now live are recorded in these stories. It is our hope that the readers of this book will enjoy the articles as much as previous readers did when they were originally published, many over ten years ago.

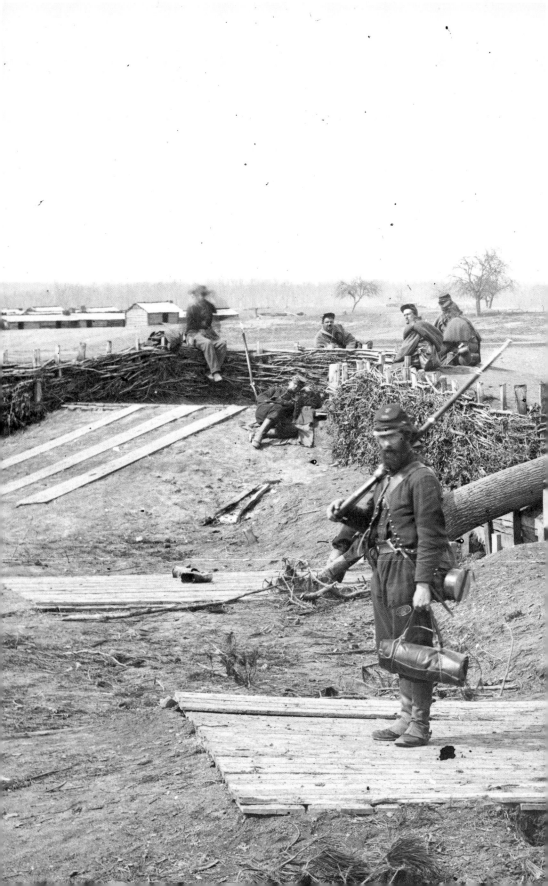

Part One

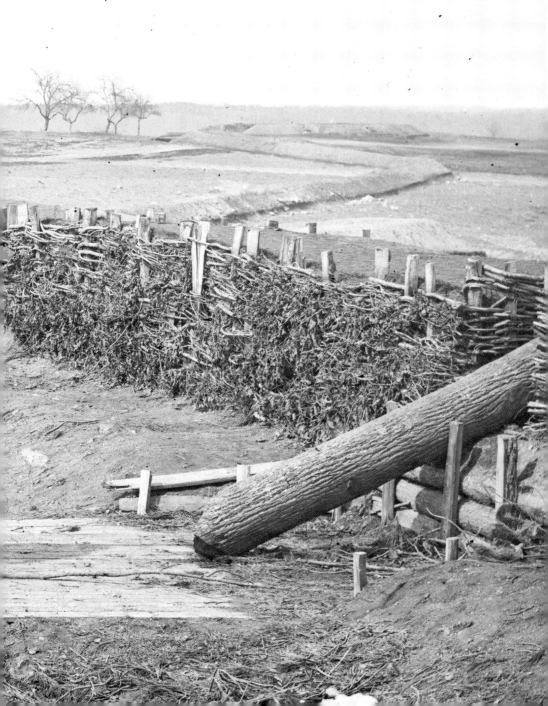

Centreville's Forgotten Fortifications

In October 1861, Confederate General Joseph E. Johnston moved most of his army of approximately forty thousand men to Centreville when it became apparent that the reinforcements needed to attack Washington were unavailable. Although now on the defensive, Johnston's army would remain in Northern Virginia for the winter of 1861–62. During that time, the army would be in striking distance of Washington and would also prevent the Union army from moving against Richmond. Johnston had chosen the location wisely because Centreville is located on a plateau, which provides an extremely strong defensive position. The descending slopes offered perfect fields of fire for a defending army. Once fortifications were complete, the position would be virtually impregnable to attack by Union forces during the remaining period of good weather.

Confederate army engineers soon had the troops busy building miles of interconnected trench lines, forts and huts that would be used for shelter during the coming cold weather. The troops were engaged in a large construction and earth-moving job with tools no more sophisticated than shovels, spades, axes and handsaws. The soldiers engaged in this manual labor must have grumbled as they worked under the watchful eyes of officers. Not all the soldiers, however, were reluctant participants. Those who had witnessed the damage that shells and bullets did to the

human body at the first battle of Manassas (Bull Run) were more than willing to pile dirt high before there was another encounter with the enemy. Confederate spies in Washington were providing reports on the continuing buildup of Union forces. President Lincoln was urging the new commander, General George B. McClellan, to move against the Confederates while the roads remained passable.

By the standards of the day, the Confederate fortifications at Centreville were substantial. There were over five miles of earthworks with thirteen forts at key positions. Over seventy pieces of artillery could be mounted along the defense line. The entrenchment line began in the valley of Cub Run, north of what is now Route 29, and followed the high ground north of Centreville. Northeast of the old village is a hill which controls the stream valleys of Big Rocky Run and Little Rocky Run. Here the Confederates constructed one of the larger forts, and the defense line turned south. From that point, the majority of the field works followed the ridgeline to where Little Rocky Run flows into Bull Run. The Centreville earthworks were the strong point on a Confederate defensive perimeter which ran over fifty miles from Leesburg to Occoquan.

Along the Centreville line, the engineers constructed many "double saps," which were two walls of reinforced earth approximately six feet high separated by a twelve-foot space. These connected the forts, which were built on knolls and hilltops. Many of the forts were fronted with a ten-foot wide, six-foot deep ditch. The sloping fort walls rose twelve to fourteen feet above ground level and were twenty feet or more in height if measured from the bottom of the ditch. The interior walls were virtually perpendicular and had to be braced with logs to prevent the earth from collapsing. Openings for cannons were located at strategic intervals in the walls. In some areas, a fortification known as a "single parapet" was built. It was a six-foot high wall of earth with a step built in the rear to permit the defenders to easily fire over the top. Since much of the defensive line was interconnected, troops could move from fort to fort along protected routes.

The autumn of 1861 was a time of high tension in Northern Virginia as rumors of the unconquerable Confederate defenses at Centreville began to filter through the Union camps around Washington. The name "Centreville" struck a degree of fear in the minds of troops who would have to attack what was widely believed to be a very strong position. Faulty Union intelligence information did not help matters. Inaccurate troop strength estimates listed the number of Confederate defenders at ninety thousand, more than double the actual number.

Although they held a strong position, the Confederates also had their problems. The usual range of diseases (diarrhea, dysentery, typhoid, measles and pneumonia) common in the Civil War began sweeping through the camps and sent many a young man to an early grave. It took a toll on the army: twice as many Civil War soldiers died of disease as were killed or mortally wounded in action. In a January 1862 report, more than 3,400 men were listed as sick and unfit for duty at Centreville.

Outnumbered, the Confederates awaited an attack by an enemy force that was growing larger every day. Bedeviled by a shortage of cannon, the Confederates painted logs black and placed them in the gun ports of many of the forts to create an illusion of massive firepower. These fake artillery pieces were known as "Quaker Guns." The supply system did not function well. Enormous excesses of some food items and clothing piled up while other items remained in short supply. To lessen dependence on roads that would be virtually impassable in wet weather, the Confederates began constructing a railroad spur from Manassas Junction to provide rail service to the camps at Centreville. It was the first railroad in the world built solely for military use.

Despite the constant wear and tear on the nerves of the troops, nothing happened. Because the Centreville defenses had General McClellan spooked, he simply avoided attacking. Autumn slipped into winter while the armies stayed in their respective positions. In early 1862, McClellan decided to bypass the strong Centreville position altogether, and began preparations to move his army south over a water route down Chesapeake Bay. That failed attempt to take Richmond became known as the "Peninsula Campaign" in the history books. In March 1862, the Confederates evacuated Centreville as Johnston shifted his army to new positions in order to block McClellan's anticipated move.

After the Confederate evacuation, Union troops and newspaper reporters quickly determined that the defenses had been manned by an army only half as large as General McClellan had estimated. That fact, along with the revelation that many of the cannons were fakes, put the first serious dent in General McClellan's reputation as a field commander. There were many people in the North who believed he had made a major mistake by not attacking Centreville.

Large armies came to Centreville twice more during the course of the war. A Union army occupied the plateau after General Pope's defeat at the second battle of Manassas in August 1862. General Meade's Army of the Potomac dug in on the high ground north and south of Centreville in October 1863. On both occasions, Confederate General Robert E.

Lee declined to launch attacks against the formidable Centreville heights, and no battle was fought.

Because they were never attacked, the fortifications at Centreville were mostly ignored after the Civil War ended. Farmers, reclaiming the land, obliterated many of the trench lines over time. Much of what remained was destroyed by road projects and residential development as time progressed. A few accessible parts of the old fortification line have been preserved and are marked with signs. An interesting section lies along Battery Ridge Lane at the corner of Stone Road. One of the forts still stands on Wharton Lane between Gresham Lane and Lawrence Mill Lane. On the east side of Pickwick Road, north of Leland Road, are located the entrance pathway and explanatory sign for two forts and their connecting trench line. This was the strong point that hinged the defenses running east-west with those running north-south. There are also a few unmarked sections that can be viewed from public roads. For example, an old trench line and artillery position can be seen on Mount Gilead Road north of Wharton Lane.

These worn mounds of earth are relics of the grim time when the mighty fortification line at Centreville, Virginia, riveted national attention as it defied the Federal army for five months. On ground now replete with yards and patios, nervous gunners once sighted their cannons and tense infantry waited behind fortifications for an attack that never came. It is also one of the few locations that General Robert E. Lee considered so strong that he twice refused to launch attacks against it. Although no battle was fought at Centreville, it had an impact on the course of the Civil War. In avoiding combat on its plateau, generals made decisions that affected their careers and caused battles to be fought at other locations.

STRUGGLE FOR THE RAILROADS

Railroads had made a major impact on the economy of the United States by the time the Civil War broke out. Land transportation costs had plunged; the time it took to move freight from New York to Cincinnati had been reduced from fifty to five days. Passenger travel time between New York and Chicago had been cut from three weeks to three days. The railroad brought increased prosperity and improved the quality of life for the people in Northern Virginia, even though train wrecks at the unheard of speed of twenty-five miles per hour were rapidly becoming a leading cause of accidental death.

In geographical area, the eleven Confederate states were virtually the same size as the eighteen states remaining in the Union. To suppress the rebellion, Union armies would have to conquer a large territory and effectively utilize railroads to move troops and supplies farther and faster than ever before. The use of this new transportation technology would prove to be a curse as well as a blessing because bridges, buildings and water tanks could be burned and tracks torn up.

As a first step, Union troops occupied Alexandria in May 1861. From Alexandria, the Orange and Alexandria Railroad ran through Manassas Junction to Culpeper Court House, then on to Gordonsville, where it connected to a line to Richmond. At Manassas Junction,

the Manassas Gap Railroad branched off, going to Strasburg and the Shenandoah Valley.

The Loudoun and Hampshire Railroad ran from Alexandria to Leesburg. After the occupation, the Union army connected Alexandria to Washington by laying tracks on the Long Bridge, which stood on the site of the present Fourteenth Street railroad bridge. On June 17, 1861, the Confederacy drew first blood in the struggle for the rails when they ambushed a train carrying Union soldiers on a reconnaissance mission about a quarter of a mile from Vienna. The engine was at the rear of the train pushing the cars. When the firing began, the engineer panicked, uncoupled the engine and one passenger car and rapidly withdrew to Alexandria. The Union soldiers were left to walk and carry the wounded back. This first tactical use of a railroad in the Civil War cost the North approximately twenty casualties.

The second round also went to the Confederates when the Manassas Gap Railroad helped them win the first battle of Manassas (Bull Run) in July 1861. Union General Irvin McDowell planned to capture Manassas Junction and then advance to Richmond. Confederate General Joseph E. Johnston slipped away from the Union forces supposedly containing him in the Shenandoah Valley and brought his troops to Manassas by rail. His railroad-riding reinforcements turned the tide against the Union.

There were some 30,000 miles of track in the United States in 1861. Of that total, about 9,500 miles were controlled by the Confederacy. The Lincoln administration established the United States Military Railroads (USMR) on January 31, 1862, to operate captured Southern railroads. Under the control of Secretary of War Stanton, the USMR utilized more than two thousand miles of track in the occupied South by the end of the war.

The military rail system was a mess in early 1862. Army quartermasters were not in a hurry to unload cars, delaying train departures and tying up badly needed freight cars. There were shortages of wood for locomotives because troops appropriated it for campfires. The soap used by soldiers fouled steam water so badly it could not be used in locomotives. Troops had to be reminded to break step on railroad bridges because the concentrated pounding of hundreds of feet hitting a bridge at the same time could shake it to pieces.

In April 1862, Herman Haupt, a brash, scrupulously honest organizational genius was called to Washington to become the USMR's chief of construction. Haupt, who preferred field service to the office, was born in Pennsylvania in 1817. He graduated from West Point in 1835 at the age of eighteen and shortly thereafter resigned from the

army to work in railroad construction. By the time of the war, Haupt had a reputation as one of the best railroad construction engineers in the country. Although he only served from April 1862 to September 1863, he radically improved the operation of the USMR and turned it into a formidable instrument of war. He installed toilet facilities in the freight cars used to haul troops. When Haupt needed trained work crews, he organized a Construction Corps (CC) composed primarily of former slaves who had fled to the federal lines. They were trained to work as a team with ax men, teamsters, framers, raisers and surveyors. Each member of a crew had a specialty. The CC worked with an enthusiasm not found among regular troops and was spectacularly successful in laying track and bridging streams in record time. Beginning with a contingent of three hundred, the CC numbered ten thousand by the time the war ended in 1865.

Haupt developed new technologies to support the CC. He designed prefabricated, standardized, interchangeable parts for bridge building and repair work, reducing construction time by more than 50 percent. One bridge foreman expressed the humorous opinion that he could assemble a bridge about as fast as a dog could trot. Replacement parts and spare rails were stockpiled at depots. Train schedules were revised to avoid idle time. An efficient courier service utilizing both the telegraph and horsemen was instituted to keep trains on schedule. Supplies were forwarded only when needed, and quartermasters were forced to punctually unload and return cars. When guerrilla attacks became a threat, the CC received training as a defense force.

Haupt and his new CC soon had their hands full. On August 26, 1862, Confederate General Stonewall Jackson captured Bristoe Station. His soldiers opened a switch and sent an oncoming engine and half of a train of cars plunging down an embankment. A second train smashed into the cars still standing on the tracks and was also wrecked. The next day, Jackson captured the large Union depot at Manassas Junction. It was quite a haul and Jackson burned what he could not use or move. General Pope's Union army met defeat at the second battle of Manassas on August 30, 1862, and his army struggled to regroup at Centreville. Haupt's crews moved five hundred tons of ammunition to Sangster and Fairfax stations to keep the army in bullets during the battle and re-supply it during the retreat.

A Union field hospital had been established on the Warrenton Turnpike (Lee Highway). As the army withdrew, the hospital was moved to St. Mary's Church. Approximately three thousand wounded soldiers were placed on

the hill between St. Mary's and Fairfax Station. On September 2, as the Confederates were advancing near Fairfax Court House, Union troops withdrew, leaving Haupt's crews in an exposed position. He instructed them to load the wounded, burn what supplies could not be removed and evacuate. Clara Barton, the founder of the Red Cross, departed with the wounded on the last train. The final telegraph message from the station agent, a Mr. McCrickett, read: "September 2, 1862; (To) J. H. Devereux: Have fired it. Good-by, McC." The Union's military railroad crews were a tough breed. McCrickett was reportedly the last man to leave the area during the retreat. He stayed behind to light the fires after the last train departed and then escaped on foot to Alexandria. It had been rough going. The USMR lost more than three hundred pieces of rolling stock and miles of track and had many bridges destroyed.

General J.E.B. Stuart, leading a cavalry force of eighteen hundred, raided Burke Station in December 1862. He captured two hundred prisoners and a large number of supply wagons, ripped up the track and cut the telegraph line. While there, he sent a snide message to Union Quartermaster General Meigs complaining about the poor quality of the mules he had just captured.

John S. Mosby and his rangers were a major impediment to the Union war effort in Northern Virginia. Many of his men appear to have been exempted from the Confederate draft on the condition that they join his force. Farmers by day and guerrilla fighters by night, they wrecked trains and burned supply wagons. During the conflict, Mosby's force killed, wounded or captured more than one thousand Union troops. The federals could not stop Mosby's attacks. To the dismay of General Lee, however, Mosby was never able to halt rail traffic for much more than a day before the CC had the wreckage cleared and the line repaired. To protect its facilities, the CC built defensive positions around the railroad machine shops and yards in Alexandria. They ran from the foot of Duke Street to Hunting Creek and were visible for many years after the war.

During the Gettysburg campaign in June and July 1863, the CC rebuilt nineteen bridges and installed water tanks and sidings on the rail lines supplying the army. Under normal circumstances these lines handled three trains per day. The CC increased the capacity to thirty trains per day and kept Meade's army well supplied.

Herman Haupt's influence extended to all theaters of the war. Many of his former subordinates served Generals Grant and Sherman in the campaigns of 1864–65. They received their basic training from Haupt and went on to apply his system wherever USMR trains moved. Thanks

to the principles and practices developed by Haupt, Sherman's Georgia campaign is considered a classic in efficient military railroading. From a base 360 miles away, the USMR supplied 100,000 men and 60,000 animals over a single-track line running deep in enemy territory. By 1864, the CC crews were so efficient that the Confederates were never able to cut Sherman's tenuous supply line for any length of time.

Herman Haupt died on December 14, 1905, of a sudden heart attack; fittingly, he was on a train to Washington, D.C. In his later years, he often complained that historians had overlooked the contribution the Construction Corps made to winning the war. Haupt had nothing but high praise for the former slaves who exhibited so much endurance and valor in keeping the rail supply lines in operation. St. Mary's Church is often open to the public. The rebuilt Fairfax Station was moved up the hill and is a railroad museum and community center. The Loudoun and Hampshire line is gone. Modern trains still run on the route of the old Orange and Alexandria. The rails are a silent monument to the members of Haupt's Construction Corps. It was their adaptability, speed and innovation that enabled President Lincoln's armies to bring the Confederacy down.

BLOOD FEUD

War can generate animosity between generals and politicians if the military and political goals do not share a common objective and are not clearly understood by the parties. In Centreville during the autumn and winter of 1861–62, war policy differences between Confederate President Jefferson Davis and General Joseph E. Johnston began to attract public attention. As the gulf in the thinking of the general and president grew wider, their working relationship slowly degenerated into a personal feud that had an impact on the outcome of the Civil War.

It was a disgruntled Confederate army that camped around Centreville in late 1861. The war had not ended quickly as the majority of soldiers expected and Southern politicians had gleefully predicted. Washington, D.C., was too strongly defended to attack successfully, so it remained firmly in Union hands. The anticipated aid from Europe was extremely slow in coming because foreign governments expressed little interest in recognizing the Confederacy as an independent nation. As the glum army settled in, its commander, General Joseph E. Johnston, opted to use Mount Gilead, or the Jameson House as it was known during the Confederate occupation, as his personal quarters. Given that the army's stay in Centreville was going to be a long one, living in a separate residence would afford General Johnston some relief from the constant pressure

and unrelenting commotion of a headquarters. It was only a short walk away from the Grigsby House, the large home that had been taken over for use as army headquarters. The Grigsby House, or the Four Chimney House as it was sometimes called, was located west of Mount Gilead at about what is now Route 28 and the entrance ramp to Interstate 66.

As the Confederate army increased its procurement of foodstuffs, services and timber, the Centreville area initially experienced a mini-boom as the local population sold supplies to government purchasing agents. However, since the Confederate government was often paying less than the going market price, the residents might have also felt the first heavy hand of confiscation as the army began to take what it wanted, slowly making payment in a currency already showing the early signs of instability.

The growing unhappiness of local civilians was the least of General Johnston's worries. The report that his nominal subordinate, General Beauregard, submitted on the first battle of Manassas insinuated that President Davis had prevented pursuit of the defeated Union army after the battle had been won. When the report was made public in October 1861, it created a host of political problems for Davis. His political enemies in Richmond used it to gleefully batter the Confederate president for his mismanagement of the war. Although he was a West Point graduate, veteran of the Mexican War, former U.S. secretary of war and U.S. senator, Jefferson Davis was proving to be far from the ideal chief executive. Many in Richmond were surprised to find that Davis, the eminently successful pre-war politician, suffered from a genuine inability to get along with people. He regarded all opposition to his programs as directed against him personally, discouraged disagreement and was unwilling to delegate authority. One exasperated observer once curtly described Davis as "cold as a lizard and ambitious as Lucifer."

Davis often quarreled with Confederate congressmen, generals, governors and the press. Never forgetting a slight or forgiving the person who committed it, Davis transferred General Beauregard out of Centreville in January 1862. The Confederate president's relations with General Johnston, then the senior commander in Northern Virginia, were equally atrocious. While the exact reasons for the bad blood between the men are unknown, it is often speculated that they had grown to dislike each other long before the war began. Some historians believe it had its roots in an obscure dispute involving their wives. Others think it began when Johnston was promoted to quartermaster general of the U.S. Army in 1860, when Davis, then a U.S. senator from Mississippi, supported another candidate.

The situation grew worse in September 1861 when Johnston learned that Davis had placed him in fourth place on the seniority list of generals. Based on his previous rank in the U.S. Army, Johnston believed he should have been at the top of the list. Enraged by the listing, he sent Davis a very impolite letter. Davis was duly insulted, refused to reconsider and fired back an icy cold reply. Davis may have used the rank placement to even the score with Johnston for the promotion to quartermaster general that he had strenuously opposed. Or, in fairness, he may have been uncomfortable with Johnston's military abilities and simply wanted to ensure Johnston would never outrank the other three generals, one of whom was Robert E. Lee. Whatever the reason, real or contrived, the feud between the two men grew in intensity.

Extremely bitter letters continued to fly back and forth between Centreville and Richmond regarding army supply issues, the need for additional troops and the conduct of overall war policy. The differences were heated; Johnston wanted to attack Washington, Davis could not provide the required reinforcements and supplies demanded by Johnston. As word of the feud spread in Richmond's political circles, Johnston became identified with the political opponents of President Davis. It was a position that, as army commander, he should have avoided at all costs because the touchy Davis began to mistrust his every action.

At a meeting in Richmond in early 1862, Davis and Johnston discussed plans for withdrawing the army from Northern Virginia. After the strategy was leaked to the press, an infuriated Johnston decided he could no longer confide in the Confederacy's civilian leadership. When the army evacuated the Centreville positions in early March 1862, Davis was not informed. To make matters worse, the retreat was so poorly organized that vast stockpiles of supplies had to be destroyed. Coming on the heels of Confederate setbacks in the west, the uncontested retreat severely damaged Southern morale. As the leader of a fledgling nation, Davis had to pay a high political price for the loss of territory. He was frustrated, humiliated and angry. The level of distrust between Davis and Johnston rose to new heights.

Fickle fortune finally smiled on careworn Jefferson Davis. At the battle of Seven Pines east of Richmond on May 31, 1862, Johnston was severely wounded and had to be relieved of command. In the best decision he made during the war, Davis selected an elderly, obscure general named Robert E. Lee to replace Johnston. The Union army was soon to learn what Davis already knew: that the courtly Lee was an expert in the art of serious warfare. Going immediately on the offensive, Lee would go on to

dominate military operations in the east during the next two years. By the time Johnston recovered, Lee had amply demonstrated his worth on the battlefield. Not even the fiercest political critic of Davis cared to argue for giving Johnston his old job back. Anxious to get Johnston as far away from Richmond politics as possible, Davis transferred him to the west after Johnston recovered from his wounds in November 1862. While Lee confronted the Union army in Virginia, Davis wanted Johnston to reverse the Confederacy's sagging fortunes and put an end to the massive Union inroads in the western theater. It was not to be. The bitterness between the two men grew deeper as Davis held Johnston partly responsible for the devastating loss of Vicksburg in July 1863.

After the command structure of the Confederate army in Tennessee collapsed in chaos in late 1863, Davis reluctantly put Johnston in charge of the army responsible for blocking Sherman's drive on Atlanta. The animosity that Johnston held for Davis continued to sour the unstable relationship between general and president as Johnston went out of his way to avoid informing Davis of his plans. Lacking clear communication from Johnston, Davis began to believe reports, including those from General John B. Hood, that Johnston was incapable of holding Atlanta. Under the tremendous political pressure brought on by the constant loss of territory in Georgia as Johnston slowly fell back before Sherman, Davis made the fatal decision that sealed the doom of the Confederacy. He relieved Johnston in July 1864 and replaced him with General Hood. The defensive-minded general, beloved by his troops, who had often stated that he could hold Atlanta forever, was no longer in charge.

Despite a mangled arm and the loss of a leg, Hood was still full of fight. He quickly reversed Johnston's strategy of ensuring Atlanta remained in Confederate hands until the war-weary Northern electorate could throw out the much-despised Lincoln in the coming election. Oblivious to the political consequences of his actions, Hood went on the offensive. Sherman's confident veterans didn't blink as they parried Hood's frantic blows. When he had spent himself, they decisively struck back. In high spirits, they marched victoriously into Atlanta in early September. The effect in the North was immediate and electric as gloom turned to euphoria overnight. The horrible, never-ending war had suddenly become winnable. In the first good news of a long, bloody summer, the great manufacturing and railroading center of Atlanta had been captured. As a direct consequence of the city's fall, Abraham Lincoln was reelected president of the United States in November 1864.

As the hope for Southern independence to be negotiated with Lincoln's successor was dashed, Hood and Davis decided to launch an audacious invasion of Tennessee in an effort to redeem Confederate fortunes. Hood got as far north as the powerful Union logistical base at Nashville, which he nominally put under siege. It was a case of self-delusion on Hood's part because in reality his army, which operated on the principles of the past, was going to meet an army testing those principles coming with the future. General Thomas brought his Union forces out of the Nashville lines on December 15, and in two days of hard fighting obliterated Hood's army in the worst defeat ever suffered by Confederate arms. Hood's force ceased to be a viable military organization as the stunned survivors fled southward on the frozen Tennessee roads.

Was the feud between President Davis and General Johnston caused by a battle of giant egos, genuine differences over war policy or divine intervention? Whatever the reason, the quarrel that grew to a fever pitch at Centreville contributed mightily to the demise of the Confederacy. One can truthfully say that the slim likelihood of Southern independence began to die at Centreville's Mount Gilead, the Grigsby House and the short walkway between. The tense psychological drama that played out in those homey places effectively crippled the decision-making ability of a president and a general for the duration of the Civil War.

THE FORGOTTEN BATTLE
BY THE MALL

The largest Civil War battle fought in Fairfax County is not well publicized because it occurred between the Confederate victory at Second Manassas (Bull Run) and Lee's invasion of Maryland. Although overshadowed by these events, the struggle at Ox Hill, which is also known as the battle of Chantilly, had a direct impact on the course of the war. It was a spectacular twilight battle, fought in the midst of a thunderstorm, in which neither side gained a foot of ground. Unfortunately for the Union army, two of its most able generals were killed in the action. Although inconclusive, the battle forced changes in Confederate strategic planning and resulted in Lee's fateful decision to invade the North for the first time.

At the end of August 1862, Abraham Lincoln was deeply troubled because his plan for crushing the Confederacy had come to naught. His military fortunes were plunging after a stunning series of reversals orchestrated by Robert E. Lee. In a lightning-swift campaign, Stonewall Jackson had swept the Union forces out of the Shenandoah Valley. Next, Lee had halted the Union army that was driving up the peninsula to capture Richmond. Now, General John Pope's army was staggering back to the high ground around Centreville after the second defeat at Manassas. Secretary of War Stanton was calling out government clerks

for a last-ditch defense of Washington. Things were so bad in the capital that Lincoln's government halted the retail sale of liquor.

Pope's defeated army did not panic as it had done the year before. His bitter and sullen troops had fought well and they knew it. The loss had come about because Lee had simply outgeneraled Pope. Although eight thousand men had been knocked loose from their commands and were drifting around Fairfax County, the heights at Centreville were a strong defensive position. It would be extremely difficult for Lee's Confederates to capture those ridges. It was a strange military situation: Pope had sixty-three thousand troops at the time of his retreat, while Lee had only forty-nine thousand. Lee, however, so psychologically dominated events that Pope only briefly considered launching a counterattack from his strong Centreville position.

Lee was looking for a decisive victory. His objective was to destroy Pope's army before it was reinforced or withdrew to the Washington defenses. Since it was not prudent to launch a frontal assault on the Centreville line, Lee decided to get between Pope's army and Washington. On August 31, he ordered Jackson's corps to move around the flank via what is now Routes 659 and 50. Jackson was instructed to move east to Fairfax Court House and cut Pope off. Lee would follow with Longstreet's corps and smash the Union forces as they tried to withdraw.

It was hot and Jackson's troops were exhausted. Many had not had a full meal since August 27 and they were unable to move with their usual speed. The weather was also uncooperative. August 31 came with rains that soaked the troops and turned the roads into quagmires. Jackson's force departed about noon and when they halted for the night, the forward elements were on Route 50 in Fairfax County. Squadrons of Stuart's cavalry division had pressed almost as far as Jermantown, where they collided with Union troops holding a line running south from Route 50 to Route 29.

On a clear and windy September 1, Jackson's forces resumed the march. His artillery units were on the road; the infantry moving in battle formation along both sides. They arrived at Ox Hill around 4:00 p.m. when scouts suddenly spotted a large Union force moving up from the south. Rattled as he was, General Pope had anticipated Lee's move around his flank and he scrambled to counter it. He sent General Joseph Hooker to take charge of the defenses at Jermantown along Difficult Run and began shifting troops to meet the threat posed by Jackson's advance. He also ordered the IX Corps to head north across country to Chantilly. Major General Isaac I. Stevens's First Division was in the lead. Stevens

was a man who stood only one inch above five feet tall. But in his case, size didn't matter. He was cherished by his troops and respected by the other officers.

About two miles east of Centreville, Stevens's First Division turned off of Route 29 on to a farm track leading north. After a twisting march of three miles, they arrived at a pasture adjoining a thirty-acre cornfield just south of Ox Hill where they ran into Jackson's troops. General Stevens observed a line of Confederate skirmishers advancing out of the woods on the north side of the fields. Without hesitating, he ordered his men to attack. His lines swept forward and the battle was on. Confederates concealed in the woods fired a volley that staggered the Union troops. Captain Hazard Stevens, the general's son, was among those severely wounded. He recovered and was later awarded the Congressional Medal of Honor for his actions at Fort Huger, Virginia, in April 1863. In 1900, he published a biography of his father.

At about 5:00 p.m., an extremely violent thunderstorm broke over the battlefield. The heavy rain and darkening sky cut visibility to almost nothing as the downpour turned the field into mud. The Confederates were at a disadvantage because the strong wind blew the rain directly into their faces. The thunder was so loud that it drowned out the roar of the cannon. Entire units lost their ability to shoot as their gunpowder became wet. Hand-to-hand fighting became the rule rather than the exception. When an officer asked that his men be relieved because their weapons were soaked, the dour Jackson told him that the enemy was also wet and instructed him to hold the position with bayonets.

Though outnumbered, the Union attackers were giving a good account of themselves because their unexpected attack had thrown the Confederates into temporary confusion. Then disaster struck as General Stevens, who had grabbed the regimental flag of a New York unit and was leading the charge in person, was killed. The attack faltered and his troops began to fall back.

Before launching his attack, Stevens had sent a messenger back to Warrenton Turnpike (Route 29) to find reinforcements. The messenger located Major General Phil Kearny who commanded the First Division of the III Corps. Kearny promptly turned his troops up West Ox Road (Route 608) and they went into action to the west of Stevens's firing line. In the pelting rain and growing darkness it was becoming impossible to tell friend from foe. Kearny rode forward to check on a report that a gap had developed in the Union line. In the driving rain he made a mistake, riding directly into the Confederate lines. The Confederates called upon

him to surrender and instead of complying, Kearny wheeled his horse around in an attempt to escape. It was a brave act, but he was too close to the enemy for it to succeed. He was shot and fell lifeless into the mud.

Shortly after Kearny's death, the battle began to sputter to an end because it was impossible for officers to maintain any sort of control over the troops. Flashes of lightning only added to the confusion as the heavy rain and thick black clouds brought on premature darkness. Around 6:30 p.m. the fighting ended as the two sides, unable to see and soaked to the skin, simply drew apart. At the conclusion of the battle, they were in virtually the same positions they occupied when it began. It had been an ugly, muddy fight with over 1,200 men killed or wounded.

Back at his headquarters, General Pope abandoned any thought of offensive action, and under his orders, the Union forces began withdrawing. Leaving their campfires burning brightly at 2:30 a.m. on September 2, they retreated back through Fairfax Court House and on to Washington. General Pope was relieved of command by Lincoln on September 5. His army was merged into the Army of the Potomac and General McClellan was put back in command.

Generals Kearny and Stevens had fought in close proximity at the second battle of Manassas. Only two days later, they both lost their lives at Ox Hill as they foiled Lee's plan to destroy Pope's army. Because of their daring attacks, Jackson was unable to cut Pope's line of retreat. About six thousand Federals had fought fifteen thousand Confederates and they had halted Jackson's advance.

Lee was not strong enough to assault the defenses of Washington. His army could not stay long in Northern Virginia because the region had been stripped of supplies. If he wished to remain on the offensive, he had to move forward quickly. As a consequence of Ox Hill, Lee decided to invade Maryland. With twenty thousand reinforcements sent from Richmond, he set his army in motion toward the Potomac River crossings.

The deaths of Generals Stevens and Kearny hurt Lincoln's war effort. Both were highly competent officers who had proven themselves in battle. They had both been promoted during the previous July and were destined to assume even larger responsibilities. Kearny had more combat experience than any other top-echelon commander in the Union army. Had he lived, it is very likely he could have become the commander of the Army of the Potomac. The Confederates removed Kearny's body from the battlefield. On September 2, General Lee ordered it returned to the Union lines under a flag of truce. Stevens's body was recovered by his New York troops. When they mustered out of the army in 1865,

they presented the flag he had been carrying to his widow as a token of their respect. There are memorial markers to Kearny and Stevens in the park on Monument Drive. These simple stone markers were placed by the veterans of Kearny's First New Jersey Brigade Society on land donated by a former Confederate officer in 1915. They are among the few remaining reminders of the time when a critical battle raged on what has become a highly urbanized part of Fairfax County.

CENTREVILLE VEXED TWO PRESIDENTS

Today, the name Centreville brings to mind a collection of suburbs, businesses, a high school and traffic jams that begin at 6:00 a.m. During the Civil War and to the generation that fought in it, the name Centreville denoted a war zone. More than two hundred thousand soldiers equated the name of the village and its environs with victory, boredom, sickness, disaster and death. Mention of Centreville put a knot in the stomach of Confederate President Davis, who visited the village on September 30, 1861, and worry lines on the face of President Abraham Lincoln. Generals saw their careers disappear there; privates cursed the bad luck that brought them to the miserable place.

In July 1861, a Northern reporter wrote, "Centreville is a village of a score or two of houses straggling along a ridge about four miles from Bull Run." It was the last time Centreville was to be mentioned in a peaceful context for many years. During the nights of July 18–20, 1861, a large part of General McDowell's Union army of 37,000 camped on the land between Lee Highway and Braddock Road. The old campground is now the subdivisions of Union Mills, Cavalier Woods and the Ponds. On the evening of July 21, McDowell's army streamed back in defeat. The disorganized troops packed the roads in what became known as the "the great skedaddle." Colonel Erasmus Keys described it as "Cavalry horses

without riders, wrecked baggage wagons and pieces of artillery drawn by six horses without drivers, flying at their utmost speed and whacking against other vehicles, produced a noise like a hurricane at sea."

Imagine the reaction of President Lincoln the same evening when he was read a copy of an urgent dispatch sent by a major in the army engineers from Centreville. The terse message said the battle had been lost; the army was in retreat and unable to re-form. It closed by urging that all available troops be put forward to save Washington. In the ensuing political chaos, Lincoln took full responsibility for his role in the defeat. He probably remembered the numbing shock of the Centreville message for the remainder of his life.

Throughout the autumn of 1861, Confederate President Jefferson Davis and his generals expected an attack on the Centreville defense line. It never came because Lincoln could not get General McClellan to move his army forward during the good days of autumn. In December, Davis received a message from General Johnston's Centreville headquarters informing him that the Yankees had a spy operating in the Confederate War Office located in Richmond. General Johnston's personal dislike of Davis and his fear of spies may have been a factor in his decision not to inform Davis when his army evacuated Centreville in early March 1862. Davis, caught unaware of the army's move, was politically humiliated. He was sharply criticized for the substantial loss of territory in Northern Virginia and the vast quantity of supplies lost as Johnston retreated. Centreville, Virginia, was not a place Davis fondly remembered.

Attracting the negative attention of two presidents cost the region dearly. In 1865, an observer noting the amount of destruction between Alexandria and the Manassas battlefields wrote, "Centreville is even more of a desert. Once a village of rare beauty, perched upon a gentle slope of a high ridge and commanding a view of fertile valleys for many miles war swept, it and its ruins lie about, invested with all the saddening influences of perfect desolation."

Women of Intelligence

The ability to gather good military intelligence was important to both sides during the Civil War. Knowledge of the enemy's plans and troop strength could mean the difference between victory and defeat. Both the Union and the Confederate armies quickly came to depend on information from spies in order to gain insight into the intentions of the opposing army. Although usually prohibited by social custom from joining military units, ladies served both the North and South quite capably as intelligence operatives. With little or no formal training in the craft, three of the women who went into espionage work made a major impact on the course of the war in Northern Virginia.

Antonia Ford was the daughter of a prominent Fairfax Court House merchant. During 1861, she passed information gleaned from the Union troops stationed in the town to General Stuart, who thought her information so good that he awarded her an honorary commission as an aide-de-camp. Ms. Ford met John S. Mosby during the first winter of the war when he was attached to Stuart's cavalry. After establishing his independent guerilla command, Mosby visited Fairfax often. He once stayed three days and rode about the town and countryside with Antonia, often chatting with Union officers. Ms. Ford was in a position to be of great help to Mosby because she was attractive and an entertaining

conversationalist. Union officers often stayed in the Ford home and Antonia took every opportunity to learn things from them.

On March 9, 1863, Mosby raided Fairfax Court House and captured Union General Stoughton. The audacious attack created a sense of vulnerability in the Union camps and raised the fear that President Lincoln and his cabinet might also become targets. While it is agreed that Ms. Ford provided the Confederates with a great deal of valuable information, it is not at all certain how deeply she was involved in Mosby's Fairfax raid. Mosby later denied that she played any part in it. That would not be surprising since no government or military organization has ever maintained a policy of confirming intelligence activities.

Nevertheless, Union authorities saw her as an accomplice. Arrested along with her father and other town residents, Antonia was held in Washington's Old Capitol Prison. Seven months later, she was released and sent to City Point, Virginia, for exchange. In September, she was arrested in Centreville and sent once again to the Old Capitol Prison on a general charge of disloyalty. Within a few months she agreed to sign a loyalty oath and was freed. Ms. Ford did not let war issues interfere with her personal life. On March 10, 1864, she married Union Major Joseph C. Willard, the officer who had once been her jailor. The couple took up residence in Washington, D.C., where Antonia died in 1871.

Rose O'Neal Greenhow (1815–1864) was the widow of a prominent Washington resident and a renowned hostess. Highly effective at obtaining information from politicians, she is credited with providing Confederate General Beauregard with the Union army's marching orders and troop strength prior to the first battle of Manassas in July 1861. Based on the information provided by Mrs. Greenhow, the Confederate government ordered General Johnston to move his forces from the Shenandoah Valley to Manassas as reinforcements. Soon after the victory, she received a message from Confederate authorities that read, "Our President and our Generals thank you. The entire Confederacy is in your debt. We rely on you for further information."

Senator Charles Sumner of Massachusetts once stated, "Mrs. Greenhow is worth any six of Jeff Davis's best regiments." Arrested and confined to her home in August 1861, she continued to provide the Confederates with military secrets garnered from her many visitors. In January 1862, she was charged with espionage and treason and confined to the Old Capitol Prison. There, she continued her spying activities and, in a desperate bid to finally be rid of her, Union authorities deported her to the Confederacy in June 1862.

In August 1863, Mrs. Greenhow was sent abroad as an unofficial diplomat for the Confederacy. In that role she continued her intelligence-gathering activities and regularly sent dispatches to Richmond. She may have been carrying sensitive political information when she decided to return to the Confederacy in 1864. Unfortunately, she drowned on October 1, when the blockade-runner on which she had taken passage was driven aground by a Union warship at the mouth of the Cape Fear River in North Carolina. Whatever important news she may have been carrying went with her to the grave. She must have been a valuable intelligence asset because the Confederates buried her with full military honors.

Belle Boyd (1844–1900) ranks among the more flamboyant of the Civil War's female spies. In July 1861, when Union forces occupied Martinsburg, Belle shot at a trooper who had broken into the family home. By the autumn of 1861, she was serving as a courier for Generals Jackson and Beauregard. During Jackson's famous 1862 Valley Campaign, Ms. Boyd is credited with keeping the general regularly informed of Union troop dispositions in the Shenandoah Valley. Much of the data she was passing to Jackson was apparently charmed from Union officers who spent too much time in conversation with Belle. Her most famous confirmed contribution occurred on May 23, 1862. After obtaining the status of Union forces in Front Royal, she ran on foot from the town through crossfire to meet the advancing Confederates. The information she brought confirmed Jackson's own, permitting him to quickly capture the town because there was no longer any fear of ambush or counterattack.

In July 1862, Ms. Boyd was arrested by Union forces and sent to the Old Capitol Prison. A month later she was released in an exchange of prisoners and shipped to Richmond. During the winter of 1862–63, Jackson's headquarters appointed her an honorary aide-de-camp, with the rank of captain. In the summer of 1863, she was arrested in Martinsburg and sent to prison again. In December, she was released and banished to the South. In May 1864, she was carrying Confederate government dispatches to England when her ship was captured. She was sent to Canada and eventually made her way to England where she married the Union officer who had been put in charge of the captured blockade-runner. She wrote her memoirs in London, became an actress and married twice more. In later life, Ms. Boyd toured the United States giving recitals of her wartime experiences.

GENERAL JOHNSTON'S BIG BARBECUE

West of Centreville, Interstate 66 passes through historic Thoroughfare Gap. At the Prince William-Fauquier county line, the highway crosses Broad Run. Next to the westbound lanes on the bank of the stream stands a stark, forlorn six-story ruin that was known as Chapman's Mill during the Civil War.

The site was perfect for a mill because Broad Run drops over eighty feet in a very short distance as it runs through the gap. The fast-moving water provided ample power to operate grinding machinery. The mill was an impressive stone structure, probably built around 1750 by slaves. When the Manassas Gap Railroad was extended past the mill in 1852, business increased and the mill was expanded around 1858 to its final six-story size. It was the pride and joy of its owner, John Chapman.

The Confederate Subsistence Department established a meat-curing facility to supply food for the Confederate armies at the mill site early in the war. Why it was located so close to the front line is anyone's guess. The Confederate government probably believed it was going to be a short war in those halcyon days when federal control barely reached beyond Washington's defenses.

By the time General Joseph E. Johnston's army settled into the fortifications around Centreville and Manassas in late 1861, the plant was

operating at full capacity. Two million pounds of meat were in the curing process and large herds of cattle were on hand for future slaughter.

When Johnston evacuated his Centreville line in early March 1862, the army had to destroy a large quantity of supplies that could not be removed. At the meat plant, troops gave the local residents all they could carry. The soldiers of D.H. Hill's brigade, who were withdrawing from Leesburg, loaded as much meat as they could jam into their wagons and took it with them. Despite the soldiers' best efforts, more than one million pounds remained when the army departed. To keep it from falling into Union hands, the torch was put to the meat stockpile. It was said at the time that the smell of burning meat carried for twenty miles. Local residents fondly remembered the smell for a long time, especially during the lean war years.

In August 1862, Stonewall Jackson's forces marched by the mill on their way to capture the Union supply depot at Manassas Junction and provoke the second battle of Manassas (Bull Run). On August 28 and 29, they were followed by the remainder of Lee's army, which drove a defending Union force out of the gap while on the way to the battlefield. General Longstreet's troops fought the Union defenders at the nearby quarry, which had provided the stones for the mill's construction, and on the mill grounds. Union sharpshooters in the building are said to have made it tough going for the advancing Confederates for a time.

The combat, growing guerilla activity and a disrupted economy combined to ruin John Chapman's mental health. He died insane in 1866, leaving no heirs. Around 1870, Robert Beverley acquired the property and it became known as Beverley's Mill. Norma Burton, the clerk at the Broad Run post office remembers the mill operating until approximately 1951. She also remembers her parents buying ground meal on Sundays in the little stone building located in front of the mill.

What was once one of Northern Virginia's most prominent early industrial landmarks is a ruin. The empty shell is a testament to the poor logistical planning and horrendous supply problems of the Civil War. That is why it was once the site of the largest barbecue ever held in the region.

THE LAST CAMPAIGN

During the Civil War, Centreville was a strategic military position. Located on high ground very suitable for defense, the village controlled the route to and from Washington, D.C. Passing near Centreville and running off to the southwest ran one of the main railroad lines to the South, the Orange and Alexandria Railroad. During the years 1861–63, supply trains and the contending armies moved up and down the railroad line between Centreville and Culpeper so often that the soldiers gave the route the unaffectionate nickname "The Centreville and Culpeper Express." As the armies marched and countermarched, the countryside took on the appearance of a wasteland in many places. Many of the trees had been cut down, fences demolished, roads rutted, farmlands torn up and houses pockmarked by bullets and punctured by artillery shells.

In September 1863, the armies of Generals Lee and Meade were facing each other across the banks of the Rapidan River south of Culpeper, Virginia Both armies had suffered recent reductions in size. The Confederate government had dispatched two of General Lee's divisions (from Longstreet's corps) to Georgia where they helped win the battle of Chickamauga. In order to aid the battered Union army then besieged at Chattanooga, the Lincoln administration rushed two of General Meade's army corps to Tennessee in a massive movement by

rail. The troop shifts left Lee with approximately fifty thousand troops while Meade had eighty thousand.

As soon as he learned of the reduction in Meade's forces, the crafty Lee went on the offensive. On October 9, his army was marching west and north around Meade's flank. By October 11, the Confederates had reached Culpeper. Although the army was advancing, conditions had deteriorated since the previous year when General Pope had been forced back over the same ground. General Lee was so crippled by an attack of rheumatism that he was forced to ride in a wagon. His army was increasingly handicapped by shortages in men and materiel. Many of its best commanders were dead, transport was in short supply and the soldiers were often hungry. Despite the difficulties, the tattered Rebel columns marched into Warrenton on October 13.

Ever the strategic gambler, Lee hoped to intercept Meade at a point along the Orange and Alexandria Railroad and force him to fight. However, Meade was not making any of General Pope's mistakes as he pulled back to keep his forces between the onrushing Rebels and Washington. Lee's attempt to intercept the withdrawing Union troops at the Broad Run Ford near Bristoe Station met with a decisive repulse. In a lopsided defeat, the Confederates lost 450 prisoners, five pieces of artillery and left 1,400 killed or wounded on the field. Despite the victory, Meade had no intention of giving battle on the ill-starred ground around Bull Run and withdrew rapidly past the old battlefields.

When the advancing Confederates reached the site of the old Union supply depot at Manassas Junction they were sorely disappointed. It had not been rebuilt after Jackson's attack in August 1862 and there was nothing usable amid the weeds and wreckage. The Confederates found themselves back in a region almost completely stripped of supplies. Lee's rickety supply organization was short of wagons, mules and horses; it was incapable of meeting the army's needs in the far reaches of Northern Virginia. The railroad, which had been destroyed by the retreating Union forces, could not be repaired in time to be of use. To stay very long in Northern Virginia would mean slow starvation. If it was going to feed itself, the army had to move quickly into an area unspoiled by war.

General Meade halted when he found ground to his liking. His Army of the Potomac dug in along the great natural defense line formed by the ridges running north and south of Centreville. In a line of battle stretching from Union Mills to Frying Pan Church, eighty thousand veteran troops readied themselves for Lee's expected attack. In line from south to north were the III Corps, I Corps, II Corps and VI

Corps. The V Corps moved into a reserve position between Chantilly and Jermantown. As Meade's forces held these positions from October 15–18, everything flammable that had been overlooked by prior troop visitations was utilized as firewood. On the plains near Manassas, Lee's nearly fifty thousand troops waited for orders as they searched for food. The two armies created the largest concentration of troops gathered in the vicinity of Centreville during the war.

Meade might be criticized for being cautious, but he was not making a mistake by underestimating the aggressive genius of Lee. His army was on comfortable terrain and he had placed Lee in a position where he must attack. Lee, knowing the strength of the Union positions, ruled out the possibility of a frontal assault. What to do next was Lee's problem. As he looked at the formidable Union line, he pondered his next move. His army could not stay in its present position for long because of the horrendous supply situation. On October 16, a chill autumn rain drenched the region making movement impossible. As he sat in his tent suffering from an attack of lumbago, Lee sadly concluded that his only course of action was to withdraw the same way he had come because he could not maneuver around Meade. The army was too weak to mount a sustained campaign in an area that held little in the way of supplies for man and beast. His resources and troops had been stretched to the limit. With no good alternative available, the army began to withdraw on October 17, slogging south through the sticky mud.

All things considered, it had been quite a feat. Lee had maneuvered Meade into a sixty-mile retreat from the Rapidan River to Centreville. By taking the offensive, Lee had forestalled the possibility of an attack by Union forces during the remaining period of good weather. Now he was being forced to withdraw because of a critical lack of supplies and the fact that Meade had denied him the opportunity for a successful attack.

General Lee could not create the wagons and other manufactured products necessary to sustain military operations. Since the Confederate government was unable to provide the required quantities, his army had gradually lost its offensive capacity. Lee's fighting efficiency was being done in by the illusions that the planter class of the South insisted were realities. The 2,500-year-old institution of slavery was dying out throughout the world. Yet, one of the cornerstones of Confederate policy was the insistence that it be maintained. That policy had put the Confederacy at odds with the tide of history and greatly reduced the possibility of foreign intervention on the Confederacy's behalf.

Southern cotton production reached four million bales per year in the late 1850s. In 1860, cotton exports accounted for a hefty $192 million out of total United States exports valued at $334 million. When the war began, the Confederate government had bet that the demand for cotton would force a lifting of the Union blockade of Southern ports. This did not happen. As cotton prices rose from ten cents to $1.10 a pound due to the blockade's increasingly effective disruption of the South's commodity exports, other market forces took over. Planters in other parts of the world rushed to put in cotton crops. United States wool production climbed from 40 million pounds to 140 million pounds per year during the war as suppliers raced to fill Union army contracts. To fill the void in sugar production, Hawaiian cane plantings increased.

The Lincoln administration shrewdly followed a policy of permitting cotton to be traded and was able to draw a fair amount of the South's crop into Northern hands. Many of the same planters who had urged on the war found it convenient to ignore the Confederate government's directive to burn cotton in order to keep it from the Yankees. They sold the valuable commodity to traders licensed by the U.S. Treasury Department. Although a number of English mills dependent on Southern cotton were forced to close, the disruption was not serious enough to bring British government intervention. The products the Confederacy assumed to be indispensable to the markets of Europe and the North were being smuggled out of the South, produced elsewhere, or replaced by substitutes. Those who went to the war believing "King Cotton" would bring foreign powers to the Confederacy's aid found they were sadly mistaken.

Lee knew all of this. He also knew that too many of the goods brought into Southern ports by blockade runners were destined for civilian consumption. There was more money to be made in moving luxuries, civilian clothes and alcoholic beverages than in hauling military supplies. Yet, he would do his duty and soldier on, jacking up the final cost of a Union victory to almost unimaginable costs in life and property. When it ended, his army would be defeated as much by a system based on economic illusions as by a determined enemy.

Although no one knew it at the time, a military era ended at Centreville when Lee's army retired. It was the last time the Confederate army of Northern Virginia would be on the offensive in the region. It was also one of the last campaigns made in the old style of warfare in which there was some respect for civilian private property. A new school of military thinking was being forged in the hellfire of the lengthening conflict. The

next year's campaigns would bring forth the champions of the doctrine of total war. Those generals who were to win the war by destroying the civilian economic base on which armies depended were about to move to center stage.

President Lincoln was unhappy with the fact that Meade had allowed himself to be put on the defensive and began his final search for a more combative general. In Tennessee that November, General Ulysses S. Grant routed the Confederate army besieging Chattanooga and sent it reeling into Georgia. In early 1864, Lincoln appointed him commander of all Union armies. Grant established his headquarters with Meade's Army of the Potomac and drove it to virtually shatter itself in the bloodiest fighting of the war as it struggled to pin down Robert E. Lee. Under Grant's direction, General Sheridan put the torch to the Shenandoah Valley and other parts of Northern Virginia. General Sherman made an unparalleled march through Georgia and the Carolinas that ripped the economic vitals out of the Confederacy. General Wilson's cavalry sliced through Alabama and western Georgia. By the spring of 1865, the Confederacy had been plunged into economic ruin. With its war-waging capacity destroyed, the war sputtered to an end after Lee surrendered his army.

Centreville witnessed the demise of national innocence in the aftermath of the first battle of Manassas in 1861. In 1863, it saw the last vestiges of the courtly type of war leave the national scene. If a monument to the wrenching psychological changes driven by the Civil War is ever erected, it should be placed in that once militarily significant village. Both it and the illusions held sacred by a generation of Americans were shattered in the course of the fighting.

DEPARTED NEIGHBORS

Late in 1997, a construction worker discovered the Washington, D.C., office used by Clara Barton in an old building scheduled for demolition. Some of her personal papers and a large number of government files regarding missing Civil War soldiers were found just as she left them when the office closed in 1868. Discovered among the artifacts was a brass sign that reads, "Missing soldiers office, 3rd story, Room 9, Miss Clara Barton." Due to the historic nature of the structure, the National Park Service has taken over the building at 437 Seventh Street, NW, and is making plans to preserve it.

Known as the "Angel of the Battlefield," Ms. Barton became notable for her Civil War nursing work. It began in 1861 as she organized efforts to recover the lost baggage of Union army soldiers. After spending the war years caring for the wounded, she established an office at her own expense to locate missing soldiers. No one knows how many desperate families searching for information on missing relatives contacted the Seventh Street office while it was in operation. Probably embarrassed by her solo performance, the federal government eventually paid Ms. Barton a flat fee of fifteen thousand dollars for her efforts. Utilizing the harsh lessons learned from her wartime nursing service, she organized the American Red Cross in 1881 and became its first president, serving in that capacity until 1904.

In late August 1862, Ms. Barton was in Washington, D.C. The city was in a panic because the armies commanded by Generals John Pope and Robert E. Lee were fighting a savage battle in the vicinity of Manassas Junction. To make space for the expected flood of wounded, three thousand convalescent soldiers were moved from Washington and Alexandria hospitals to medical facilities as far away as New York and Philadelphia. The government ordered all hacks and carriages in the city seized for use in transporting convalescents from the hospitals to the railroad depot.

Because General Pope's main supply depot at Manassas Junction had been destroyed before the battle began, his forces were short of supplies. On August 29, his army reported that it was out of fodder and food and short of ammunition. On August 30, U.S. Military Railroad (USMR) authorities sent a terse message from the Alexandria depot stating, "One hundred and fifty tons of ammunition are now loading on cars for Pope's army." The shipments were sent to Fairfax Station because the advancing Confederates had destroyed trains, track and bridges at points further west. True to its word, the USMR soon had at least eighty-eight cars of ammunition and other supplies moving to Fairfax Station.

During the fighting, many of the wounded were relocated to St. Mary's Church near Fairfax Station. During this frenetic time, it is believed that Ms. Barton hitched a ride on one of the USMR supply trains running out of Alexandria. After arriving at St. Mary's, she worked day and night tending the two to three thousand wounded lying on the grounds. However, not all of Washington's citizens were as much help as Clara Barton during those critical days. Herman Haupt of the USMR was infuriated with the "drunken rabble" called out by the war department to serve as nurses. He reported that of the nearly one thousand volunteers, nearly half of them were drunk and useless.

When the firing finally stopped, General Lee had won a smashing victory. Pope's defeated army fell back to the Centreville heights to regroup. Reports indicate that over twenty thousand stragglers from Pope's army were scattered between Alexandria and Centreville on August 31. Keeping a watch for the wily Lee's next move was a major task for the Union forces. A dispatched order said simply, "All disposable cavalry should watch Vienna and Falls Church."

It had been a major collision of veteran troops. Approximately twenty-four thousand Union and Confederate soldiers had been killed, wounded or listed as missing. The number of casualties overwhelmed the medical services of both armies and many of the unattended wounded were

dying in the heat. On August 31, Lee wrote to Pope, "Sir: Consideration for your wounded induces me to consent to your sending ambulances to convey them within your lines."

The stench of death hung in the air. Wrecked railroad engines which cost $8,500 apiece at the time and railroad cars ($500 each) were strewn along the Orange and Alexandria tracks. On the battlefield, the dead were being hastily buried while many of the wounded crawled or walked into fencerows, ravines and creek bottoms to escape the heat, search for water and often die. As Pope's army began to withdraw to the defenses of Washington, the USMR crews hastily crammed the wounded into the empty rail cars at Fairfax Station, set fire to the military facilities and pulled back to Alexandria. Clara Barton, now launched in a new career, is reported to have departed on the last train. A historical marker commemorating her efforts stands near the church. When Lee's troops arrived, they found only smoking ruins and the dead that had been left behind.

Bad as this second clash of arms near Manassas was, worse was yet to come. The fighting would go on and on. As the number of dead increased, the war came to the doorstep of General Lee's home. In 1864, with the existing cemeteries near Washington filled to overflowing, Union authorities seized part of the Lee family property at Arlington, Virginia, for use as a cemetery. By war's end, sixteen thousand graves had been dug there. Ironically, some of those who died fighting against Lee during the hot August of 1862 eventually were buried in his yard. Near his former home, known as Arlington House, stands the tomb of the unknown Civil War dead. Erected in September 1866 over the remains of Union soldiers, the inscription reads in part, "Beneath this stone reposes the bodies of two thousand one hundred and eleven unknown soldiers gathered after war from the fields of Bull Run and the route to the Rappahannock." With the Civil War burials, Lee's property was on the way to slowly becoming what we now know as Arlington National Cemetery, a national shrine.

Also near Lee's house is an equestrian statue of General Philip Kearny. He lost his left arm in the war with Mexico in 1847 and his life on September 1, 1862, at the battle of Chantilly (Ox Hill). He was killed halting Jackson's attempt to turn Pope's flank. The ugly fight brought the campaign of Second Manassas to an end and added another 1,200 casualties to the rolls. The old office on Seventh Street in Washington and Lee's mansion in Arlington National Cemetery are places that illustrate the high human cost of making military history. One was the working space of a dedicated woman who treated the wounded, searched for missing soldiers and

organized civilian disaster relief. The other was the home of a remarkable general. His property became the final resting place of some of those who waged war in what would later become our neighborhood.

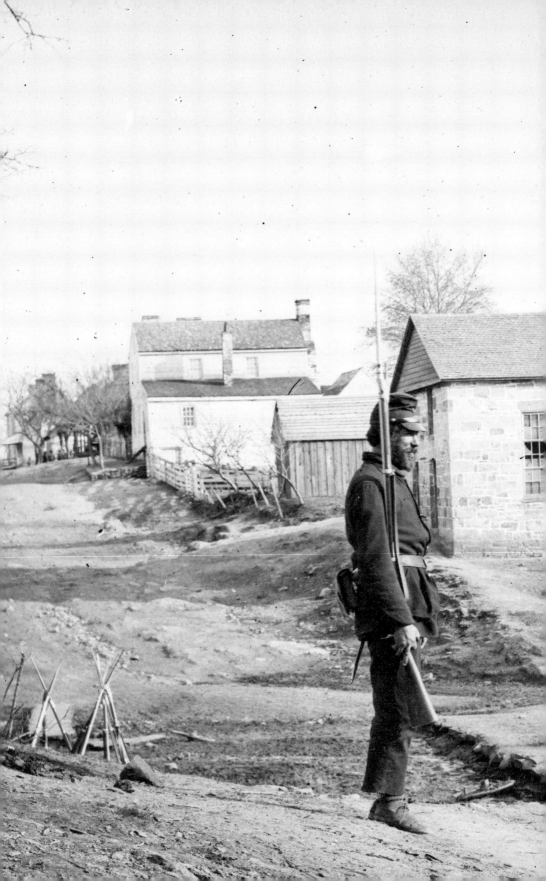

Part Two

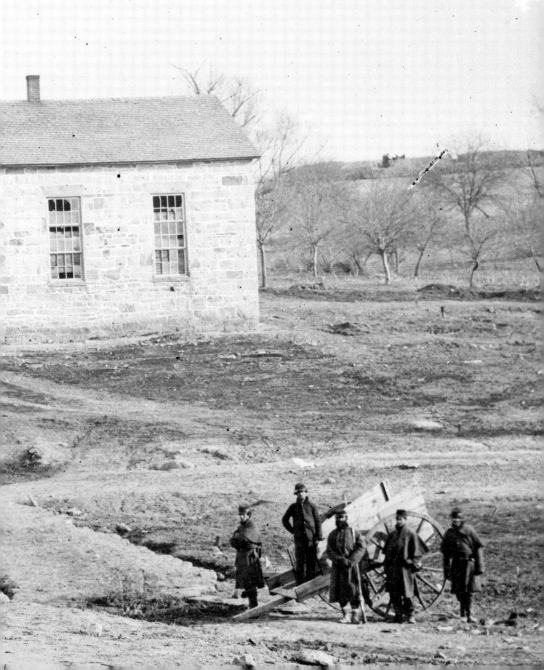

HOUSE OF SHATTERED DREAMS

One of old Centreville's largest and most impressive homes was the Grigsby House, sometimes called the Four Chimney House. It stood at the north edge of the village on Braddock Road near the point where Braddock Road once crossed Route 28. Built sometime between 1769 and 1787, the dwelling was a large two-story wooden structure with four massive stone chimneys, two at either end of the house. It was the home of Alexander Spotswood Grigsby, one of Centreville's leading businessmen in the years preceding the Civil War. Grigsby bought and sold slaves, speculated in real estate and owned part interest in a store. The Civil War probably disrupted his business ventures because little is known of his activities after he voted for Virginia's secession in the balloting of May 1861. After the war in 1866, Grigsby sold most of his Centreville holdings and moved from the area.

In 1921, J. Harry Shannon, a reporter for the *Washington Star*, noted the historic relevance of the Grigsby House when he wrote, "That house with its broad outlook over fields that were to be smoky and bloody, was the headquarters of McDowell in July 1861." Shannon was referring to Union army General Irvin McDowell, a career military officer who graduated from West Point in 1838 and was a veteran of the Mexican War. An artillery specialist by training, he was brevetted for his actions at Buena

Vista. While serving in the adjutant general's department in Washington, he became an acquaintance of Secretary of Treasury Chase, thereby forming a relationship that helped him get the job of commanding the troops stationed in Washington when the Civil War broke out.

Prodded constantly to take the offensive by President Lincoln, General McDowell reluctantly put his army on the march, reaching Centreville on July 18, 1861. Looking for a place to locate his headquarters and most likely impressed with the size of the house and the great view to the north and west it offered, General McDowell set up shop in the Grigsby House. He spent the next two days resolving logistical problems, sending out reconnaissance parties and developing his battle strategy. His final attack plan was a solid but complicated piece of work, taxing the abilities of his beleaguered officers and raw troops to the maximum. On Sunday, July 21, General McDowell's dream of military glory was rudely shattered when his army was defeated at the first battle of Manassas. As the retreat began to turn into a panic, McDowell established a rally line on the Centreville heights, hoping to regroup his forces on the high ground. The line collapsed as his defeated troops, losing all semblance of military cohesion, scampered back to Washington.

The battle plan devised by General McDowell in the Grigsby House also shattered Abraham Lincoln's dream of putting a quick end to the Confederacy. President Lincoln had seen the solution to the problem of secession as a simple one. Attack the rebels at Manassas and defeat them, then capture Richmond and the war would end. In later years as the war raged on, Lincoln would often relate to his confidants how public opinion and his cabinet officials had pressured him to order McDowell's ill-fated advance. He had yielded to those demands and defeat followed. Had his officers been allowed more time to train the troops, Lincoln admitted sadly, the outcome might have been different. Apparently no one had ever advised the president of an accepted military tenet: an army undertaking offensive operations has to be better trained than one acting in a purely defensive role.

General McDowell's career never recovered from the effects of the defeat at Manassas. Relieved from army command upon his mortifying return to Washington, he established a mediocre record in subsequent field assignments as a corps commander. Eventually relieved of all combat responsibility, he was posted to the Department of the Pacific during the last years of the war. General McDowell was a modest, friendly man who holds the distinction of being told by President Lincoln that "both armies are green alike" when he asked the president for more time to train his

soldiers. He is now remembered mostly for his role in the spectacular failure at First Manassas and his ability to consume gigantic quantities of food during meals.

Despite the hard luck reputation it gained as McDowell headquarters, the Grigsby House continued to attract military officers. When Confederate General Joseph E. Johnston moved a major part of his army to Centreville in October 1861, the Grigsby House was selected for use as army headquarters. It was only a short walk from Mount Gilead, the house serving as the personal residence of General Johnston. Confederate officers went to work designing the fortifications that would make Centreville nationally famous during the autumn and winter of 1861–62. The troops were deployed and cannon emplaced, able and willing to repulse the expected Union attack. No attack ever came and when Johnston withdrew from his lines in early March 1862, the dream of a Confederate military force powerful enough to camp unmolested on the doorstep of the federal capital came to an end. As his army marched away, a large part of Northern Virginia was lost to the Confederacy.

Much like its military occupants, the Grigsby House also had a run of bad luck. By 1901, it was an abandoned ruin with holes in the walls and roof. By 1921, the main structure had collapsed, with only three of the four big chimneys still standing, rising above a tangle of mulberry trees and bushes. Most of the large foundation stones were removed and put to other uses when Route 28 was widened in the 1940s. By the early 1950s, nothing remained except an undistinguished mound of rubble on the east side of Braddock Road. Later road improvements eventually obliterated those remains. What had been one of the most photographed buildings in Centreville during the early Civil War years was gone. The traffic moving from northbound Route 28 to Interstate 66 East now zooms over the site where the Grigsby House once stood, a place where major military decisions were made in 1861–62.

Old Centreville's Ugly Secret
The Slave Trader

For over half a century, the issue of slavery generated an increasing amount of tension between the North and South. In Congress, the best minds of the nation struggled endlessly with the problem and crafted a long series of political compromises in efforts to defuse the issue. Over the years, all the compromises eventually failed. The result was the secession of the Southern states and the Civil War. The troublesome institution of slavery finally came to an official end in the United States with the passage of the thirteenth amendment to the Constitution. Congress proposed the amendment to the state legislatures on January 31, 1865, during the closing months of the Civil War. It was declared ratified on December 18 of the same year, having been ratified by the legislatures of twenty-seven of the thirty-six states. It brought to a close the era in which human beings were legally treated as property to be bought, sold or traded like any piece of equipment or livestock.

Slavery was also prominently featured in the constitution of the Confederate States of America. Article 1, Section 9 of the Confederate Constitution contains a clause expressly prohibiting the passage of any law "denying or impairing the right of property in Negro slaves." In other words, the institution of slavery was of such high importance to the founders of the Confederate government that it was firmly protected

in the first article of their constitution. Although the concept of owning human beings is difficult to comprehend today, it was a normal part of life in Centreville less than 150 years ago. In those days, a slave was a piece of property whose value fluctuated with market conditions, age, skills and ability to work. Slave owners, much like today's car owners, differed in the ways they cared for their property. Some treated their slaves almost like hired hands, living in close proximity and working alongside them in the fields. Others watched their overhead costs closely and provided the minimum care required to keep the slaves productive. At the other end of the spectrum were the owners who were downright malicious, abusing and on occasion killing their slaves. These individuals were not considered to be murderers by their contemporaries; they were considered to be people who misused and wasted very expensive assets.

Slavery existed in the world for thousands of years and many of the early civilizations, such as Greece and Rome, depended upon the use of slave labor. Slavery came early to North America and flourished for two hundred years despite its racial degradation and high cost in human misery. Slavery began in Virginia around 1660 when the Commonwealth began to switch from a system of indentured servant labor to slave labor. The slave system grew stronger and concentrated in the South as the nation developed. On the eve of the Civil War, it was a viable, robust institution and in no danger of dying out.

Alexander Spotswood Grigsby was a prominent local businessman and slave dealer. To understand the impact of the slave trading enterprise Alexander Grigsby managed, we have to view him in the context of the time in which he lived. He was part of an economic system that saw nothing immoral or wrong with using slave labor. Slavery was a fact of life; it was an important part of an agricultural system that produced valuable commodities and earned hefty incomes for the large slave owners. Lewis Leigh, a member of Historic Centreville Society, has an extensive collection of Civil War material and has been kind enough to provide a copy of a letter Alexander Grigsby wrote in July 1855 to his business associates in Richmond. The document provides an interesting look into the slave dealer's life.

The letter begins:

> *Gentlemen,*
> *Will you be kind enough to let me know what has become of*
> *Asaph. Hill. He carried out a Negro man for me last fall and*
> *I have never heard hair nor hide of him since. If you know*

anything of him please write to me. I have a few Negroes on hand that I cannot spare at the present having a large crop on hand and should like to buy a few more before I come down. And would be glad if you would let me have about two thousand dollars until I do come down which will not be more than sixty or seventy days. I hope you won't feel any doubts on account of the failure of some men engaged in the traffic. For I will certainly attend to it about that time. If you can do it send me a check on Alexandria or Leesburg and I will immediately return my note for the same. And at the same time give me the prices particularly for a young woman with one child and also with two children.

Respectfully yours, A S Grigsby

The letter indicates that one of Mr. Grigsby's slaves has disappeared along with a Mr. Hill, who was responsible for delivering the slave. Grigsby stands to lose money because the slave is missing. His business reputation may also be in danger of being damaged because Grigsby is making it clear to his associates that Hill is at fault for the non-delivery. Grigsby goes on to mention that he has a number of other slaves on hand, but wants to keep them working in Centreville until after the harvest is in. He also wants to buy a few more slaves before making the trip, most likely to Richmond since that is where he addressed the letter. He goes on to ask for a two thousand dollar cash advance to cover costs. The loan, secured by his note, is to be repaid when he travels some two months later. He closes his letter by asking for the price of a female slave, one with one or two children. Grigsby may be checking prices because he has a pair he plans to sell or he may have a buyer interested in making a purchase and wants to obtain the current price.

Two thousand dollars was a great deal of money in days prior to the Civil War. To put it in context, one dollar in 1860 would have the purchasing power of over twenty-two dollars today. So at today's prices, Alexander Grigsby is asking for an advance of over forty thousand dollars to finance slave purchases. And the debt is to be secured only by his note. From his correspondence we have learned that slave trading involved large sums of money. We also need to know what it was like to live in the days when Alexander Grigsby was running his store and slave dealing in Centreville. In what kind of environment did he work?

First of all, the agricultural practices of the period were doing a great deal of damage to the land. The standard practice of the time was to clear

the land and then raise crops continuously until the soil gave out. After the soil was exhausted, the farmer would pull up stakes and move further west to start the cycle over again. Between the American Revolution and 1850, approximately one million Virginians moved west as a result of the cycle of land ruination. As a result, the state fell from first place in national population ranking to seventh place by 1860. Those Virginians moving to new slave states took their slaves and attitudes with them. The families that moved to the free states often converted to anti-slavery positions within a generation of leaving Virginia.

Daily life was a lot tougher for people in Grigsby's time. The average life expectancy was fifty-five years. Public health practices hadn't changed much during the previous hundred years and epidemics of diseases such as smallpox, cholera and yellow fever routinely swept through the population with terrible effect. At the time Mr. Grigsby was in business, slave ownership in the South was fairly widespread. Half of the families in South Carolina and Mississippi owned slaves. About a quarter of the families in Virginia, Maryland, Tennessee, North Carolina and Texas were slave owners. In Virginia in 1860, there were 490,864 slaves included in the total state population of 1,600,000. In Fairfax County, 529 owners held title to 3,116 slaves. The county's total population was 11,800. Throughout the South, about 50 percent of owners owned less than five slaves, while 72 percent owned less than ten. Around 45,000 planters had more than 20 slaves. These were the wealthiest families in the South.

These slave owners also had a large degree of political power. In October 1862, the Confederate Congress passed a bill making anyone owning twenty or more slaves exempt from military service. The exemption caused a great deal of resentment among the common folk and gave rise to the bitter saying in the Confederate army that this was "a rich man's war and a poor man's fight." Approximately three thousand Southern families owned more than one hundred slaves. They were the wealthiest of the wealthy. This was an elite group and they controlled the destiny of the South politically and economically. Jefferson Davis, the man who became the president of the Confederacy, came from this class of powerful slave owners. His Brierfield Plantation, located below Vicksburg on the Mississippi River, grew from 800 to over 1,500 acres over time and was worked by over one hundred slaves. Davis was earning over thirty-five thousand dollars per year from his plantation while he was serving as a senator from Mississippi in Washington, fighting slavery's political battles in Congress. Joseph Davis, Jefferson's brother, did even

better. He was the wealthiest planter in the state of Mississippi and he helped Jefferson get his start as a plantation owner.

In 1808, in one of the early political battles over slavery, Congress made the importation of slaves from Africa illegal. Although importing slaves from Africa was prohibited, the selling and transport of domestic slaves within the United States remained a normal business practice. Slaves could be bought and sold like any other property. They had transferable titles. They were sold through newspaper ads, by commission merchants, brokers and auctioneers. Of the Atlantic and Border States, Virginia ranked first as an exporter of slaves to the Deep South. Between 1830 and 1860, three hundred thousand slaves were sold out of the state. The magnitude of the interstate trade led to charges that Virginia was in the business of slave breeding. It was true. However, the notion was not insulting to Virginians of the time. Thomas Dew, a Virginia legislator, proudly referred to Virginia as a "Negro-raising state" as early as 1831. As crops changed from tobacco to grains and vegetables in Virginia, the sale of excess slaves was a source of stable profit for farmers. They responded to the Deep South cotton boom by exporting large numbers of working-age slaves. Depending on the section of the state, up to 30 percent of the slave population was sold and shipped out of state in the decade of the 1850s.

Slave traders such as Alexander Grigsby were key figures in the system. As a dealer, he was always looking for marketable slaves. The faster he could move slaves between his sellers and buyers, the higher his profit margin. It was a very risky, speculative and competitive business. Dealers such as Grigsby worked on a mark-up of about 30 percent. Mr. Grigsby did not have a completely free hand to do as he pleased because there were laws governing his business conduct. He had to ensure the owners got clear titles and he had to warrant the physical soundness of the slaves he sold.

A slave infant was valued at around two hundred dollars at birth. Young Negroes aged ten to thirty were the most in demand. Slave children generally were considered fit to work at the age of ten. Slaves were shipped south on ships or marched overland in groups of twelve or so in a chain gang called a coffle. The majority of slaves were relocated south during the months of October to May. As a dealer, Alexander Grigsby must have known some of the speculators who bought sick or ill slaves cheaply and then sent them to doctors who specialized in curing them. Their ads read, "Slaves unfit for labor bought on reasonable terms." Once back in working form, the rehabilitated slave was sold at a profit.

Alexandria became a major slave-trading center. The firm of Franklin and Armfield started operations in 1828 and ran until 1836. It became the largest slave-trading enterprise in the nation, earning its principals profits of a half million dollars each before the panic of 1837. The firm shipped one thousand slaves a year to the Deep South, many on its own fleet of ships. Joseph Bruin appeared on the scene a bit later and ran a slave market in Alexandria during many of the same years that Alexander Grigsby was active in Centreville. Bruin advertised that he was at all times in the market for young Negroes for the South and would pay liberal prices for all Negroes from ten to thirty years of age. A writer named Harriet Beecher Stowe became familiar with the details of Bruin's business. She is reported to have used her knowledge of Bruin's operation as background for her anti-slavery novel, *Uncle Tom's Cabin*, which became a bestseller in the North after it was published in 1852. In the South, however, sales were dismally poor, another sign of the growing sectional rift.

Maintaining the health of slaves was an important topic of the day. The literature of the times featured articles encouraging slaveholders to learn how to recognize the symptoms of "Negro Consumption" because it could quickly spread and destroy the slave's value. Agricultural periodicals also carried interesting articles giving sage advice to owners. One study of slave reproduction flatly concluded that "Your Negroes will breed much faster when well-clothed, fed and housed." Fredrick Law Olmstead, the noted landscape architect who designed New York City's Central Park, was no lover of slavery; he often criticized the system in articles he wrote. But he was forced to admit during one of his frequent visits to the South that the profit gained from the use of slave labor in Alabama and Mississippi was as good as the return obtained from any other type of investment.

Today we consider the slave trade to have been a brutal and vicious endeavor. Prior to the Civil War it was a fact of Southern commercial life and was treated as such. In the 1860 City of Richmond business directory, there are listings for such businesses as saloons, barrel factories, blacksmiths, wheelwrights, undertakers and so forth. Right after the listing for music teachers is the heading "Negro Traders." Fifteen firms are listed.

A dealer, Mr. Isaac Franklin, lost some of his slaves to cholera while they were awaiting sale in Natchez, Mississippi. Obviously upset by the loss, Franklin dumped the bodies in a swamp so the potential purchasers of his living slaves would not be scared off. It became something of a scandal in the trade after enraged local planters found the bodies. They threatened to bring legal action because Franklin's inconsiderate act of disposal had exposed their slaves to the dreaded disease. The *Staunton*

Spectator, in the issue of October 11, 1859, carried an article noting that the exodus of slaves from Virginia and North Carolina was having a negative effect on local agriculture. The exported slaves were being sent to Alabama, Mississippi, Arkansas and Texas.

Slave prices were low from the panic of 1837 to the mid-1840s, and then they shot up. By the 1850s, slave prices were higher than ever before. The price of a prime field hand went up 115 percent between 1840 and 1860. Not every marketable slave in Northern Virginia was being sold because there was a local rental market serving those interested in renting out the services of their slaves. As such, many residents of Fairfax County made good money by hiring out their slaves. The annual hiring rate usually equaled 10 to 20 percent of the slave's value. In 1859, a top field hand was renting for $225 a year. A skilled deck hand could bring his owner as much as $480 a year.

Slave labor was distributed across a wide spectrum of occupational categories. Not all slaves worked at unskilled jobs in the cotton fields. About 15 percent were domestic servants and cooks. Another 10 percent were skilled workers in trade and industry. They worked in such varied occupations as coopers, seamstresses, blacksmiths and seamen. Some rose to the level of top managers. The best overseer Jefferson Davis had on his Mississippi plantation was a slave named James Pemberton. After Pemberton died in 1850, Davis had a difficult time finding a capable replacement. No one Davis tried or hired was able to fill Pemberton's shoes and Davis greatly missed his services.

Arlington County, which was once part of the District of Columbia, is now part of Virginia. The slave trade had a lot to do with the transfer of sovereignty. In 1846, the residents of Alexandria City got themselves reattached to Virginia partly out of the fear that the slave trade in Washington, D.C., would be abolished. Alexandria's fears were not groundless; there was continuing interest in abolishing the slave trade in the nation's capital. As part of the ongoing effort, Congressman Abraham Lincoln proposed a bill in 1849 for the compensated emancipation of slaves in the District of Columbia. Lincoln's bill did not pass; however, he did get a second chance. As president, he signed the 1862 District emancipation law passed by Congress. On April 14, 1862, Congress appropriated one million dollars to compensate the owners of freed slaves. Loyal Union masters were paid $300 for each slave they freed. Over the next year, approximately 3,100 slaves were freed under the program. The District of Columbia Emancipation Act is the only example of compensated emancipation in the United States.

The period between 1840 and 1860 was a time of economic expansion in the United States. All across the nation things were in a flux and slavery was a major source of regional discord. As Alexander Grigsby went about his business in Centreville, the massive transformations occurring in the national economy were pushing the North and South toward the Civil War. The pace of life was changing rapidly because the industrial revolution was underway. Workers were leaving the farm to build machinery, dig coal and move products to markets by railroad and steamship. Railroad track mileage increased from just twenty-three miles in 1830 to nearly thirty-one thousand miles in 1860. By 1860, 20 percent of the population was living in urban areas. The period between 1810 and 1860 saw the highest rate of urbanization in American history. It was fueled by the growth of manufacturing in the North, which employed 45 percent of the labor force. And a quarter of the manufacturing employees were women. The textile industry in New England was booming; the number of cotton spindles doubled in the U.S. between 1840 and the eve of the Civil War. In 1860, the U.S. population reached sixty-two million, of which four million were slaves. At the same time, scattered throughout the South were the often-overlooked 260,000 free Negroes who owned property collectively valued at 25 million dollars.

Along with the upheavals caused by the growth of the manufacturing sector, the country's population mix was rapidly changing. In the decade of the 1850s, two and a half million new immigrants came to the United States. Seven out of eight of these foreigners settled in the free states. The population growth in the 1850s was twenty times higher in the free states than in the South. As a consequence, political power in the U.S. House of Representatives shifted in favor of the free states. The South was also having a hard time holding on to its population. Three times as many people migrated from the South to the free states as vice versa due to the lack of economic opportunity. In the year 1859, a little-noticed but significant national event took place. For the first time in the nation's history, the value of manufactured goods exceeded the value of agricultural products. Milled flour was the number one manufactured product in the United States. Iron products ranked second.

The wages and hours people worked were far different in Grigsby's time. What he and others in America considered as normal, we now view as intolerable. In 1860, the average industrial workday was twelve and a half hours. Workdays of sixteen hours were not uncommon in summer. In winter, a nine to twelve hour day was not unusual. It was not uncommon to report to work at 5:00 a.m. and work until 7:30 p.m.,

with half-hour breaks for lunch and dinner. In 1860, the average factory wage was about $20 per month or $240 per year. A worker spent about 50 percent of earned income on food. Today, we spend a little over 10 percent. A farm of seventy-five to one hundred acres in size provided an excellent income and lifestyle for a farm family. A farmer could earn a yearly profit of $150 and be doing well.

Only 18 percent of the nation's manufacturing capacity was in the South. There were more cotton spindles in the city of Lowell, Massachusetts, than in the entire South. The South imported two-thirds of its clothing and manufactured goods from the North. In the South, cotton production increased rapidly, increasing tenfold and driving up slave and land prices in the process. Only 5 percent of the cotton produced was used at home: 70 percent of Southern cotton was shipped abroad and 25 percent went to the North. Southern cotton came to dominate the world market, providing three-fourths of the world's supply and accounting for three-fifths of total U.S. exports. With such a large foreign market for cotton, influential Southern leaders began to believe the South could do quite well for itself as an independent nation. It would be free of Northern meddling and would thrive on the income from its cotton exports.

Slaves in the U.S. had an estimated value of three billion dollars in 1860. They were the major property asset in the South. To put it in perspective, the value of slaves about equaled the total value of the nation's railroads, factories and banks. Slaves in top condition were selling at $1,000 to $1,500 each on the eve of the Civil War. The price of cotton was up to 11.5 cents per pound and four million bales per year were being produced in the late 1850s. Sugar and tobacco prices were also up. So much land was devoted to commodity production in the Deep South that those states had to begin to import food products.

The South was remaining rural. Between 1800 and 1860, the percent of Northern labor engaged in agriculture dropped from 70 to 40 percent while the South stayed at a constant 80 percent agricultural labor rate. One fed-up Southern observer said, "the goal of the Southern economy was to sell cotton to buy Negroes and make more cotton to buy more Negroes." His statement was correct because Southern capital was being invested in land and slaves and not in other enterprises.

About one thousand slaves per year were escaping to the North. The financial loss to slave owners added to the sectional friction because many in the North were aiding and abetting the escapes. The strong feelings slavery evoked led to new laws. In the late 1840s, Virginia passed a law sentencing a person to twelve months in jail if he or she was convicted

of making the argument that slave owners had no right to their property. As the national argument over slavery intensified, it became a moral issue, deeply dividing regions and groups within regions. As the strident religious arguments for and against slavery flew back and forth, the contending positions only hardened. Slave owners used religion to justify black slavery. They looked to the story of Noah's curse on his son Ham; since Ham's descendents were believed to have settled in Africa, they were destined to be slaves. Many pamphlets written from 1836 onward used these religious arguments to defend the slave system. Of course, the abolitionists in the North and South heatedly argued the opposite. They saw slavery as sinful; it was a crime against humanity. The planter class of the South came to be viewed as a corrupt, heartless aristocracy dedicated to preserving a debasing and stagnant way of life. The growing split in religious views affected church congregations. The Methodist Episcopal Church split into Northern and Southern conferences.

This was the edgy and changing world in which Alexander Grigsby managed his business affairs. From his business invoices, we know that his store furnished merchandise to customers at least as far away as Leeton, to the north of Centreville. Copies of his rental agreements reveal that some of the slaves he owned or managed were leased to other area residents under the standard terms of the time. As the years went by, Alexander Spotswood Grigsby probably encouraged the drift toward the war that would split the nation. He firmly believed he was looking out for his own best interest when he voted for secession in the balloting of 1861. Given Virginia's status as a slave supplier, it is easy to understand why those with a financial interest in the slave system would opt to join the Confederacy. After all, no slave trader in Virginia made any money by selling slaves to the Northern states.

Carl Sandberg described the time before the Civil War as being one "of newspapers North and South lying to their readers and pandering to the cheaper passions of party and class interest, of the men and women of the ruling classes North and South being dominated more often than not by love of money and power." It was also a time of vast and growing contradictions between the population's ethical and economic positions. While the New England abolitionists railed against the slave system, Southern merchants and planters owed two hundred million dollars to the Northerners who financed them. Alexander Grigsby believed he had good reason to act as he did. In Grigsby's day, as in the present, ideology and self-interest are often so intertwined as to be indivisible. It is a human trait that has not changed.

General John Pope
A Hard Luck General

Union General John Pope is one of Centreville's most infamous temporary residents, having made his headquarters at Royal Oaks before and after the second battle of Manassas during the summer of 1862. Although nothing remains of Royal Oaks today, the residence was located on the east side of Braddock Road just north of Lee Highway (Route 29). Royal Oaks was a frame house of two stories plus an attic, with two stone end chimneys, built about 1770. It was supposedly named for the trees that at one time lined the drive running from Braddock Road to the house. Royal Oaks survived the Civil War and was in good repair and occupied in the early 1950s. In 1959, the house was dismantled and moved to Fauquier County, where it was never reassembled.

Mr. J. Harry Shannon, a roving reporter, wrote for the old *Washington Star* newspaper under the pen name of "The Rambler." He traveled, often by walking, throughout Virginia, writing about and sometimes photographing the historic sites and structures that were disappearing due to the ravages of time. In a 1921 article relating his experiences in Centreville, he described it as place where "The Civil War threw such a glare upon the village that the eyes of the world were on it." He documented Royal Oaks as "a big frame house about 200 yards back from the dusty street, overshadowed by old Locust trees." And as "A

frame house with a front porch and a set of wooden stairs leading to it at the middle." Shannon also mentioned the glass-insulated pins he noticed on the house during a previous visit. These insulated pins, he said, "once supported Civil War telegraph lines." Noting General Pope's celebrated use of the house as an army headquarters, Shannon stated that for a time previous to his current visit, the dwelling had been a place where tired travelers could eat and sleep, a hotel run by a Mrs. Simpson, now deceased. The person Shannon found occupying Royal Oaks in 1921 was a Mr. Jim Dobbins, described as "one of the prosperous farmers of the Centreville neighborhood."

At the present time, Centreville's Historic District contains many vacant tracts. Shannon's vivid commentaries help explain why many of the structures that survived the war are no longer standing today. At the time of his visits, many of the buildings were in a poor state of repair. He noted that Centreville, despite its enormous wartime importance, never seemed to have recovered from the ravages of the Civil War. He saw it as a small quiet village of dusty roads, sunken graves and buildings in need of restoration. Although Centreville was slumbering, Shannon thought it significant enough to visit because of its role in the Civil War.

Of all the commanders who left their marks on Centreville, one of the most controversial was General John Pope, a man with enemies on both sides of the conflict. While campaigning in Virginia, he was the only Union commander to earn the personal animosity of General Robert E. Lee. Apparently, John Pope was not a likeable man; he was intensely unpopular with many of the Union troops under his command in Virginia. The wording of his military orders inflamed Southern resistance and insulted his own soldiers. By misjudging General Lee's intentions, General Pope led his army to defeat at the second battle of Manassas. Soundly trounced there, he has gone down in history with a badly smeared record. Many modern historians view General Pope as an incompetent swaggering braggart, a bombastic imbecile who was completely fooled by Lee. He is also accused of committing the unpardonable military sin of blaming others for the mistakes he made in battle.

In reality, General Pope may not have been quite as inept as his record in Virginia indicates. His many enemies may have been able to reduce his memory to a contemptible caricature of the man he really was. Although he was a failure in Virginia during his short tenure from June to September 1862, he was successful in other military assignments before he arrived in Virginia and after he left. John Pope's excellent connections probably helped him rise in the army ranks. He was a distant cousin of George

Washington and was connected by marriage to President Lincoln. A graduate of West Point in 1842, Pope was a career military officer, a trained topographical engineer. He fought with distinction at Monterrey and Buena Vista during the Mexican War and was brevetted for gallantry. At the onset of the Civil War, he was in Maine serving on lighthouse duty. As the Union army rapidly expanded, Pope was appointed a brigadier general of volunteers. After capturing New Madrid, Missouri, and Island No. 10 in a campaign that opened the vital Mississippi River to Union ship traffic up to those points and set the stage for the capture of Memphis, Pope was promoted to major general in March 1862. When Lincoln brought him east to launch a campaign against Lee, General Pope was unfortunately handed much more responsibility by the president than his talents merited.

After Pope's stinging defeat in Northern Virginia, a chagrined Lincoln quickly sent him into exile. He was given command of the Department of the Northwest, arriving there in time to participate in putting down the Sioux uprising in Minnesota. By all accounts, he recovered from his debacle in Virginia and did well in the job. So well in fact, that in 1866, the citizens of Minnesota named a new county after him. General Pope commanded other departments (mostly in the west) during the remainder of his career. He retired from the army in 1886 as a highly respected authority on Indian problems and conditions on the frontier. General Pope died at the Old Soldiers and Sailors Home in Sandusky, Ohio, on September 23, 1892. All that now remains as a remembrance of his wartime stay in Centreville is a stone wall on the east side of Braddock Road, part of the property that once contained the house called Royal Oaks. Although his military reputation in this region is forever tarnished, General Pope's later exploits are fondly remembered by the residents of Pope County, Minnesota.

The Bungler's Road

Some time after 1755, the Mountain Road, one of the main roads in the Centreville area, began to be called Braddock's Road. Over a period of time, local usage simplified it further to Braddock Road, the name by which it has been known for over a hundred years. Just how and why the name change came about is not clear. Some work was probably done on the road as General Braddock prepared his army to move against the French at the beginning of the French and Indian War. Although a few British units may have used the road, it is more likely that Braddock's main force moved from Alexandria through Georgetown to Frederick, Maryland. From there, the army marched to Fort Cumberland (now Cumberland, Maryland), where it halted to gather supplies before moving against the French at Fort Duquesne (now Pittsburgh).

Given the circumstances surrounding General Braddock's subsequent defeat and death, it seems strange that anyone living in Virginia at the time would want to remember the man. While there is no doubt that Braddock was a brave general, he was also arrogant and unreasonable. Those faults impaired his judgment, and being unwilling to adapt his tactics to local conditions, he led an army to destruction. Although it would not be apparent for many years, General Braddock did have an impact on the military education of George Washington. For that

unwitting contribution to the training of the future commander of the Continental army, he deserves to have a road named after him.

Newly promoted Major General Edward Braddock arrived at Hampton Roads in February 1755 with two regiments of regulars to assume command of all British forces in North America. England and France were beginning an epic struggle for the control of a large part of the continent as well as colonial possessions in other parts of the world. It was a war for empire that would be fought on a global scale. At a meeting in Alexandria that April, Braddock laid out his plan for attacks against French positions in Nova Scotia, Fort St. Frederick on Lake Champlain and Fort Niagara on Lake Ontario. These assaults, along with Braddock's drive against Fort Duquesne, would crush the French in North America.

Braddock's British Regulars were augmented by nine companies of Virginia militia. Being a stern regular, Braddock had nothing but contempt for these local soldiers. He considered them lazy, apathetic and useless. Naturally, there was a great deal of friction between General Braddock and the militia officers who had seen service on the frontier. One of these officers was a skilled surveyor by the name of George Washington. Braddock and Washington had heated words over the value of the militia and the need to utilize the Native American Indian tribes as allies in the war against the French. Braddock could not be persuaded; he simply had no use for Indians. He considered them ignorant, painted savages of no value at all to a sophisticated military operation. The general contemptuously disregarded the advice of Washington and other subordinate commanders. He also curtly dismissed the offers of assistance from tribes friendly to the English. It was a decision he would live to regret because the Indian warrior had no equal when it came to waging war in the forests.

Edward Braddock believed he knew how to conduct a war on behalf of the King of England. He would fight his campaign according to the rules of traditional European warfare and teach the local bumpkins a lesson in military tactics in the process. After much difficulty in gathering supplies, his army of approximately 2,200 departed Fort Cumberland on June 10, 1755. The impressive British force made slow progress as it cut a twelve-foot wide wagon road through the forested mountains. Its destination was the French installation of Fort Duquesne, which controlled the Ohio River at its source, the confluence of the Allegheny and Monongahela Rivers. While the British were struggling with logistical preparations, the French garrison stationed there had not been idle. Their pleas for

assistance had brought over six hundred Indian fighters to the fort, some from as far away as Detroit.

The supply wagons and artillery struggling over the rough new road were slowing the advance. On June 19, a frustrated Braddock decided to split his forces. The majority of the wagons and a strong guard detachment were ordered to follow behind the main force at the best speed they could maintain on the miserable trace being hacked through the forest. Braddock pressed forward with 1,459 soldiers, 30 wagons, the artillery and a number of packhorses.

Although progress remained slow, by Wednesday, July 9, 1755, Braddock's force was only seven miles from Fort Duquesne. Even though there had been no sign of the French, precautions against ambush had been taken. Flanking parties were moving on both sides of the army and an advance guard was well out in front. Behind the main body of troops came the wagons and packhorses followed by a strong rear guard. The Monongahela River had been forded without opposition. Braddock soon expected to lay siege to the fort.

The French commander, knowing the fort could not withstand a siege by such a large force armed with artillery, was considering evacuation. After much discussion, he reconsidered and granted Captain DeBeaujeu permission to lead a force against the English in an attempt to slow down their advance. Unfortunately for General Braddock, this French captain clearly understood the value of his Indian allies. He gave a rousing speech to the chiefs prior to leading his mixed force of approximately 890 from the fort. Over 630 Indians came with him; the remainder of his force was a mixture of French regulars and Canadian troops.

Using an uncomplicated attack plan, the French and Indians moved down the path toward the Monongahela ford until they collided with Braddock's advancing army. While the French regulars and Canadians held their ground in front of the British, the Indians infiltrated the flanks. When the firing began, the British troops formed their standard tight formations and poured volleys of musket and cannon fire into the trees at an invisible enemy. The British advance guard and flank contingents were either killed or driven back to the main force as the Indians went into action. The sound of the tomahawk and war club smashing into English skulls soon mixed with the din of musket fire. The tightly packed British Regulars were confused because this was not how they had been trained to wage war. They continued to fire volley after volley into the trees, rarely scoring a hit. The French and Indians, firing from cover, riddled the exposed English columns from all sides. Their musket balls sometimes

passed through two soldiers before lodging in a third. The British soldiers were going down in heaps, and the French could not believe their good fortune. What had begun as a desperate delaying action was turning into a complete victory.

When the first shots were fired, the Virginians moved among the trees and began to return fire from cover. For a time, they gave as well as they got. However, the dispersal of the militia enraged General Braddock. He would not permit his troops to act like cowards and hide behind trees. He bravely moved everywhere on the battlefield, cursing his troops and shouting at them to return to the ranks. He beat soldiers with the flat of his sword, driving them from the safety of cover back into the rapidly thinning British firing lines. The battle had raged for nearly three hours when General Braddock realized that his army was being destroyed. Shortly after ordering a retreat, he was struck by a musket ball and seriously wounded. He was carried from the field by the fleeing survivors. So complete was the English rout that the French did not bother to pursue. General Braddock died on July 14 as his badly mauled force retreated toward Fort Cumberland. He was quickly buried, and the location of his grave obliterated so his body would not fall into enemy hands.

It had been a terrible disaster for the English. Braddock's force had been decimated, losing 977 of those engaged. For the small French garrison and its Indian allies, it had been a glorious victory at unbelievably low cost. French losses numbered sixteen, while the Indians counted their losses at forty. The news of Braddock's defeat sent a shock wave through the English colonies. The major general commanding British forces was dead, and his army nearly wiped out. It was now clear that war waged in the forests of the colonies could not be fought according to European standards. Nor were the French going to be quickly dislodged from their holdings in North America.

Although he had two horses shot out from under him and four bullets passed through his clothes, George Washington survived the battle. He continued to serve in the militia and was with the British force that finally captured Fort Duquesne in November 1758. The young officer of the "useless" militia that General Braddock so derided also went on to play an important role in a later war and eventually became the first president of the United States. His early association with British generals gave him a keen insight into British military thinking and strategy. It is very likely that the bitter lessons learned during General Braddock's ill-fated expedition served him well when he became the commander of Continental forces during the American Revolution. Without the experience gained from

Braddock's terrible defeat, George Washington may not have become a superb military commander later.

Edward Braddock lies buried somewhere in Pennsylvania. Did the people around Centreville have a premonition of things to come when they renamed the road so long ago? Be charitable and think kindly of "Braddock the Bungler" the next time you drive on the road that was named for him. His disaster may well have been the foundation on which our good fortune has been built!

CENTREVILLE AND THE GENERALS

The village of Centreville is a prominent feature on Civil War-era military maps. Its location on an upland that controlled the surrounding countryside made it a good defensive position. Roads also converged at the village, making it important to the military planners of the day because an army located at Centreville controlled access to the railroad at Manassas Junction and the road to Washington. Union General Irvin McDowell's army camped around Centreville prior to the first battle of Manassas in July 1861. General Joseph E. Johnston noted the excellent topography, and his Confederate army occupied the area from October 1861 to March 1862. During the war, the roads of the village were often choked with soldiers, cannon and wagons. As a consequence, the village and the countryside around it were denuded as armies moved across the region.

The Centreville known to Civil War commanders also became a casualty of the war. Situated between the present Route 28, Lee Highway and Route 66, little remains of the wartime village. The carcasses of dead mules, broken wagons, abandoned guns and piles of amputated human limbs are long gone. The army camps, fortifications and the graves of soldiers have faded into the landscape along with most of the buildings that existed at the time. During the Civil War, the Warrenton Turnpike (now Lee Highway) did not follow its present straight course over the

Centreville plateau. Climbing the grade from the east, the turnpike turned right following the route of Braddock Road and made a left turn just past the Stone Church. From there, it ran southwest to rejoin the present highway. The awkward zigzag in the road later became a hindrance to the growing number of trucks and automobiles. Around 1925, it was removed when Lee Highway was rerouted to its present course.

Late in the day on August 27, 1862, General A.P. Hill's division of General Thomas J. (Stonewall) Jackson's Confederate Army Corps marched into Centreville from Manassas Junction. Although many of the troops had been in the area before, it was not a joyous occasion because they sensed another battle was fast approaching. The soldiers moved with the steady gait of veterans who wasted no motion and spoke few words. Even though they were in a region soon to be swarming with Union forces, it was an unhurried, almost pleasant march. Unlike on previous visits, the troops paid little attention to the houses and gardens in the dilapidated little village because their haversacks were bulging with recently acquired supplies. The column leisurely made the turn at the Stone Church and headed down the turnpike toward the bridge over Bull Run.

The previous day, Jackson's three divisions had, after a hard march into the Union army's rear, captured the Union supply base at Manassas Junction. The troops spent most of the next day eating their fill and removing what supplies they could cram into their limited number of wagons. Because communications with Washington had been cut, it took the Union authorities some time to figure out what had transpired. When General John Pope, the Union commander, realized Jackson's entire corps was now deep in his rear, he set his forces into frantic motion in an effort to trap him. However, Jackson had no intention of waiting around to be smashed by a superior force while his gaunt soldiers gorged themselves on captured supplies. He burned what remained of the supply base and moved to a new position two miles from Bull Run, northwest of the first Manassas battlefield. As a diversion, Hill's division was sent to Centreville to mislead the enemy into believing Jackson's entire force had withdrawn in that direction.

A very unhappy General Pope arrived at the smoking ruins of his supply base around noon on August 28. Looking at the evidence left for him, he concluded that Jackson had retreated to Centreville in an attempt to escape, so he ordered his forces to concentrate there. The first Union troops arrived in the village about dark, but found no Confederates. By that time, Hill had completed his movement of diversion and rejoined

Jackson. The reunited force had spent the day resting in the shade of the trees north of the turnpike, not far from the old battlefield.

General Jackson began to think that Hill's ruse might have worked better than planned because Pope's army was rapidly concentrating at Centreville. They could not be permitted to remain there while General Lee and the remainder of the Confederate army came up because Pope could not be attacked on those highly defensible heights. On the other hand, if Jackson provoked a battle too soon, the larger Union army could crush his smaller force before assistance arrived. Never one to avoid a calculated risk, Jackson decided to draw Pope's army away from the Centreville heights and he began to look for something to use as bait.

On the evening of August 28, unaware of Jackson's concealed position north of the road, elements of General Rufus King's First Division (Third Corps) were marching east on the turnpike toward Centreville under orders to join General Pope. These unsuspecting Union troops presented the opportunity for which General Jackson had been anxiously waiting. After scouting the Union column himself in the early evening hours, Jackson decided to attack. Speaking softly, he instructed his officers, "Gentlemen, bring out your men." With those fateful words, Stonewall Jackson deliberately revealed the position of his troops and ignited the second battle of Manassas. It all began at a rather undistinguished location called Brawner's farm, a place that soon earned a notation in military history.

To their credit, the stunned Union troops did not break when the howling Confederates came storming forward from their concealed positions. They quickly faced left, established a battle line and returned fire. Separated by only eighty yards at some points, the blue and gray lines blasted each other for one and a half hours. When darkness finally halted the firing, neither line had budged. Union losses amounted to 1,100 while the Confederates lost 1,200, including the wounded Generals Taliaferro and Ewell. Almost one-third of the seven thousand men engaged became casualties in the furious battle on Mr. Brawner's property. It would be remembered as one the toughest close-quarter fights of the entire war.

Because he wanted to avoid fighting at Centreville, General Jackson had provoked a bloody beginning to a vicious battle that raged for the better part of two more days. When the campaign finally ended, over twenty-five thousand soldiers had been killed or wounded.

The Brawner farmhouse that is situated on the north side of Lee Highway (Route 29) has become part of the Manassas National Battlefield Park. Although the old house is in a serious state of disrepair and closed

to the public, there are explanatory markers showing the locations of the units that fought on the evening of August 28, 1862. They had come from Virginia, Georgia, North Carolina, Alabama, Indiana, Wisconsin and New York. It was on this site that a large number of men and boys marching to Centreville on a hot summer evening came to the end of their lives in an unexpected evening battle. The next morning a Confederate officer described the Union position as "marked by the dark rows of bodies stretched out on the broomsedge field [a native grass that grows in poor soil], lying just where they had fallen, with their heels on a well-defined line." A few miles to the east of the farm are the Centreville heights, which were of such importance to General Jackson and other Civil War commanders. That high ground, once of major strategic concern during wartime, now rests under a mantle of schools, businesses and houses. Few of the current residents remember the appalling price paid by a generation of soldiers when the village was of the utmost interest to the generals.

Dusty Blue Columns on the Roads

The spring and early summer of 1863 were warm and dry; so dry that by June the corn crop in Northern Virginia was in danger of failing. Rain was desperately needed for the sake of the parched crops and to dampen down the dust on the roads. In early June, Lee's Confederate army began to move north. The Second Corps, which would soon be followed by the remainder of the army, marched through Chester Gap in the Blue Ridge Mountains and began moving in Shenandoah Valley toward Winchester. On June 13, the Union army began to leave its camps along the north bank of the Rappahannock River, shadowing Lee's forces and moving on the east side of the mountains. All the roads leading to Manassas, Centreville and points north were suddenly jammed with columns of dusty blue-clad soldiers, cannon and wagons.

Units of the Union army's Fifth Corps hurried northward in some of the hottest weather they were to experience during the war. The march to the hamlet of Gum Spring (located north of present-day Route 50 on Gum Spring Road at modern Arcola) was remembered as one of the hardest marches of the entire war. Men fell out from exhaustion and thirst, a number of soldiers dying from sunstroke. Nearly every regiment left almost half of its men lying ill along the roadside. One of the regimental commanders, Colonel Joshua L. Chamberlain, suffered

a case of sunstroke and was taken to a house in Gum Spring to recover. Chamberlain, a college professor turned soldier, had almost been done in by Northern Virginia's scorching heat.

Luckily for the Union cause, he would recover and go on to become one of the most remarkable leaders of the Civil War. As Chamberlain's Twentieth Maine Regiment moved on to Aldie, he was left behind to recuperate. After supporting the cavalry in the fighting around Middleburg, the Maine troops crossed the Potomac River at Edwards Ferry east of Leesburg. Chamberlain recovered from his near fatal encounter with the heat and rejoined his troops.

He would be awarded the Congressional Medal of Honor for his gallant action in holding the end of the Union line at Gettysburg. Wounded six times during the course of the war, Chamberlain reached the rank of major general by the time the war ended. He participated in the attack that broke Lee's Petersburg line at Five Forks. After leading part of the force that cut off Lee's retreat at Appomattox, General Chamberlain was given the honor of accepting the Confederate surrender. As the Confederate troops marched up the Richmond-Lynchburg Road to lay down their weapons on April 12, 1865, Chamberlain ordered his soldiers to give an unforgettable military salute to the men of Lee's defeated army. Virtually forgotten now is the fact that the man who became one of the Civil War's greatest Union heroes almost never made it beyond Gum Spring during the course of a hard march in Virginia's blistering heat.

THE GENERAL'S
MOMENTOUS DECISION

G eneral Joseph E. Johnston had a well-established military
reputation at the time he slipped away from the Union forces in the
Shenandoah Valley and brought his troops to Manassas Junction in time
to play a major role in the Confederate victory of July 1861. Earlier in
his career, he had been wounded fighting in the Seminole and Mexican
Wars. Brave to the point of recklessness, his ability to attract enemy fire
on the battlefield made other officers nervous to be in his presence. Rising
steadily through the ranks, Johnston had reached the prestigious position
of quartermaster general of the U.S. Army when he resigned to join the
Confederacy, an act that gave him the distinction of being the highest-
ranking regular army officer to join the South.

Johnston made Centreville the focus of national attention when, as the
commander of Confederate forces in Northern Virginia, he established
his headquarters in the village and placed a major portion of his army
around it during the autumn and winter of 1861–62. At a time when
embarrassed politicians in the North and South were coming to terms
with the fact that their predictions of a short war were wrong, Johnston's
army was virtually camped on the doorsteps of Washington. General
McClellan, the opposing Union commander, believed Johnston had a
superbly trained army of ninety thousand waiting behind his defensive

line. The Confederates were known to be thirsting for blood and praying for the Union army to advance and shatter itself against Johnston's impregnable Centreville earthworks. The reality was quite different during those clear autumn days. Johnston had only about forty-five thousand troops, not all trained. It was the very real lack of men and supplies that was keeping Johnston on the defensive.

General Johnston's ability to attract enemy fire continued to haunt him. At the battle of Seven Pines east of Richmond on May 31, 1862, he was severely wounded and was replaced as army commander by Robert E. Lee. Transferred west by Confederate President Davis after recovering from his wounds in November 1862, Johnston's reputation began to tarnish. Davis removed him from command of the army defending Atlanta in July 1864. His many detractors derisively called him, "Retreating Joe, a second rate general, an incompetent." His supporters believed that Johnston's problems were mainly caused by the hostility of President Davis. They argued then, and continue to do so now, that Johnston was actually one of the Confederacy's most effective generals, every bit as good as Robert E. Lee. Johnston is admired for having shared the rations and hardships of his men. The Union generals who fought against him held him in high personal esteem and considered him to be a dangerous opponent on the battlefield. As the Confederacy collapsed, General Lee re-called Johnston to active duty in February 1865. Lee put him in charge of the ragged army trying to halt Sherman's epic march through the Carolinas. In early April, as Johnston's inferior force fell back before Sherman's army, Lee's army was driven out of the Richmond/Petersburg defenses, pursued to Appomattox Court House and forced to surrender.

Although Lee's army was out of action, President Davis wanted the war to continue, no matter what the cost. He began advocating a new phase in the war, calling for the population to wage guerrilla warfare if all else failed. General Lee was against the Davis policy. When a scout from Mosby's Rangers slipped into Richmond and asked for instructions after Lee had returned to the city, Lee bluntly told him to tell Mosby "to go home and help rebuild the shattered fortunes of our state." Although opposed by Lee, the continue-the-war policy espoused by Davis had a degree of support. Many in leadership positions in the South thought there could be nothing worse than accepting a peace based on the restoration of the hated Union. Continuing the terrible struggle was better than accepting such humiliating subjugation. The Confederate army officers remaining in the field were split in their views. Some saw the war as irretrievably lost and further resistance as futile, while others were willing to continue the fight.

After leaving Richmond, the Confederate government was on the run. Davis was hoping to get across the Mississippi River and keep the war going from a new seat of government. As Davis and his shrinking official entourage fled into North Carolina, all eyes focused on General Johnston and his twenty-two thousand troops. Unlike Lee, Johnston still had options open to him. His army was not surrounded, nor was he on the verge of complete starvation. Davis ordered Johnston to take his men and fall back out of Sherman's reach. If that wasn't possible, Johnston was ordered to break his army into small bands and take to the hills to keep up the fight.

Making a decision with ramifications that echo through history to this very day, General Johnston committed an act of outright insubordination and defied President Davis. Instead of retreating and fighting on, he surrendered his forces in late April 1865, saying, "It would be the greatest of crimes to continue the war." Although President Davis was horrified by the act, Johnston's courageous decision reconfirmed the policy established by General Lee. One by one, the remaining Confederate commanders followed the example of Lee and Johnston and laid down their arms. The soldiers were not going to support the Davis program of waging a protracted guerrilla war. It had been a hard war; approximately 620,000 lay dead. One-fifth of the manpower of the South and one-twelfth of that of the North had gone to their graves during the course of the struggle. If the same percentage of casualties were incurred by today's U.S. population, the dead would number in excess of five million. We are in debt to General Joseph E. Johnston. His brave act of presidential defiance helped bring the Civil War to an end and ensured the healing of a nation.

When Centreville Had a Stranglehold on Washington

During the summer of 1861, Confederate General Joseph E. Johnston ordered his heavy artillery into positions along the Potomac River. By the end of October, they had the capital of the United States, Washington, D.C., virtually blockaded. Johnston placed cannon in positions along the Potomac River's Virginia bank, from a point south of Occoquan Bay to where the Quantico Marine base is now located, and they began firing on Union navy and commercial ships heading upriver to Washington. With the river abruptly closed to commercial traffic, over forty vessels were soon stranded below the batteries. Although the Union navy constantly dueled with Johnston's gunners and managed to maintain control of the river proper, the vital Potomac was effectively closed as an avenue of commerce. Soon sixty ships a day were arriving in Baltimore from where the freight and passengers had to be transported to Washington by rail. The daily number of rail cars moving to Washington rose to more than four hundred. The rail effort was supplemented by one hundred teams and wagons hauling freight on the road between the capital and the port of Baltimore. If anyone cared to make the observation at the time, he or she would have noticed that the Union response to Johnston's blockade was an early indication that the industrial might of the North was going to play a vital role in the conflict. Although held in contempt by the

planter class of the South, Northern industry could produce the rail cars, wagons, ships, armaments and other equipment necessary to keep a city supplied or an army in the field. Although Johnston's blockade caused the residents of Washington a high degree of discomfort, it had no chance of starving the capital into submission because of the vast array of other logistical resources available to Federal authorities.

Still, Johnston's blockade was an embarrassment to the Lincoln administration. Naval vessels traveling to and from the Washington Navy Yard had to shoot their way past the river batteries. It also greatly increased the costs of supplying the city because the majority of commercial shipping would not risk running the Confederate fire. To counter any Confederate attempt to cross the river and stir up trouble in southern Maryland, General Joseph Hooker's division was sent to occupy the Maryland shore opposite the Confederate guns. The Potomac soon echoed with the sound of artillery fire as Hooker's long-range batteries dueled with the Rebel guns on the opposite shore. Despite the Union artillery's best efforts, Johnston's guns could not be permanently knocked out of action. During the winter, Hooker developed a daring plan for an amphibious attack across the Potomac to capture the gun positions and remove once and for all the irritating obstacle to commercial traffic. It was a good plan and indications are that it would have worked. However, nothing ever came of it because Hooker's superiors would not approve it.

Poor General Joe Hooker is now remembered mostly for his disastrous loss to Robert E. Lee at the battle of Chancellorsville in 1863. The fact that he had a keen interest in the ladies also brought him a degree of fame, which lasts to the present day. His last name has become an occupational title for the class of women engaged in prostitution. Had he been permitted to carry out his plan to storm the Confederate gun positions on the Virginia shore, history might have cast him in a more favorable light. A "Hooker" could have quite easily become the name used to denote a swift military strike to destroy artillery positions located on the other side of a wide body of water.

When the Confederates pulled out of Northern Virginia, they were forced to abandon their river batteries and the Potomac River reopened to shipping. The blockade of Washington had come to an end.

FAIRFAX COUNTY'S
DISTINGUISHED INDUSTRIALIST

George Washington was born in 1732, the younger son of a second marriage. His father's untimely death dashed young George's chances for an education in England and left him with only a modest inheritance. When his mother blocked his attempt to join the British navy, George was heartbroken since he wanted to go to sea and follow in the footsteps of Lawrence, his older half-brother.

From all accounts, George rebounded quickly from his mother's stern quashing of his plans for a seafaring career. By the age of sixteen, he had become a surveyor, a lucrative and respected profession for a young gentleman of little property. Surveying paid well in England's colonies because it was responsible, challenging and often dangerous work. As such, mother Washington's fears for her son's safety on the sea might have been misplaced because his new profession was probably much riskier. At the time Washington took his equipment into the woods, there were perhaps 1.6 million inhabitants scattered in a thin band along the east coast of what was later to become the United States. The geographical center of population was approximately thirty miles east of Baltimore, Maryland. Winchester, Virginia, was an outpost on a tense frontier because England and France were at growing odds over control of much of eastern North America. The agents of the edgy, contesting empires were not above

inciting the native Indians to discourage interlopers, so being killed while working on the frontier was not an uncommon way for one to die.

Upon the early death of Lawrence, George Washington assumed the management of Mount Vernon, his brother's plantation. Along with his lifelong interest in agricultural science, Washington also had a deep appreciation for the application of technology to industrial production. In 1770, wishing to take advantage of the growing market for flour and other grain products fueled by the Industrial Revolution, Washington decided to risk his capital and build a new gristmill near the head of Dogue Creek. It was a large commercial facility, accessible to the ocean-going ships that would transport the barrels of flour to markets outside of Northern Virginia. Along with mills that he owned in Alexandria, Virginia, and Pennsylvania, the Dogue Creek mill would make George Washington one of the largest flour producers in the colonies.

Washington's gristmill utilized the best available waterpower technology. The sixteen-foot diameter water wheel was located inside the building, making it a style found more commonly in New England than in Virginia. Water moving through a control chute at the end of the millrace struck the wheel near its top and filled the buckets mounted around the circumference of the wheel's face. As the weight and force of the water caused the wheel to rotate downward, it turned an axle connected to a series of wooden gears. These gears turned the shafts, which powered the grinding stones and the other mill equipment. The waterwheel rotated approximately eleven revolutions per minute, producing a whopping twenty to twenty-five horsepower. Wooden gears driven by waterpower were what Northern Virginia high tech was all about in the late 1700s.

A dam and millpond located approximately one and a half miles upstream from the mill supplied the water. Although no traces remain today, these structures were most likely located in what has become the Jackson Miles Abbott Wetlands Refuge on the military reservation of Fort Belvior. A hand-dug millrace, lined with stones, delivered the water from the pond to the mill, following the contours of the land as it flowed downhill. Since Washington was a skilled surveyor, he probably did the survey work himself. Despite Washington's best efforts in dam and millrace construction, the mill operated at peak efficiency only for about six months of the year. A shortage of water hindered operations during the dry, summer months and freezing temperatures often halted the water flow at times during the winter.

The hillside location chosen by Washington for the gristmill afforded access to the structure on two levels, reducing the labor necessary for

unloading grain wagons. Shrewdly, he also installed two sets of grinding stones in the facility, enabling the mill to produce a wide range of products. The expensive, imported French Buhr stones ground fine flour for the "merchant trade," as Washington called it. Much of this product was sent by ship to cities along the east coast and in the West Indies. The other set of rougher granite stones ground the corn and the other grains produced in the fields of Mount Vernon for home use and local sale. The mill also served the region's other farmers, charging one-eighth of the grain volume as a milling fee. Work in the gristmill went on from sunup to sundown. The danger of fire and explosion from the grain and flour dust made night operations too risky in the days when candles provided illumination. For his services, the miller was paid a salary of $166 per year, provided free housing in the nearby miller's cottage and given the use of a garden plot.

In the 1780s, Oliver Evans, a native of Delaware, developed equipment to automate flourmills. His ingenious water-driven conveyor system moved grain and flour throughout the mill, sharply reducing the cost of milling operations. Because of the impact his innovations had on the milling industry, Evans is considered by many to be the father of early American industrial automation. To protect his rights as an inventor, Evans was among the first to be granted patents by the new United States government. Ever attuned to new technical developments and their application to his endeavors, Washington had the Evans-designed equipment installed in the Dogue Creek mill in 1791.

Over time, Washington developed a sizable industrial complex on the mill property. By 1798, along with the mill, there was a cooperage manufacturing barrels, a large distillery containing five stills producing whiskey, a hog fattening lot and stalls for thirty head of cattle. Apparently, Washington saw to it that nothing that arrived on the site was wasted. What could not be turned into flour or whiskey went to feed the animals. By the standards of the day, the site was a beehive of activity. His whiskey makers ran the profitable distillery at full capacity while the busy coopers constructed the barrels to be used in transporting Washington's products. As grain wagons made deliveries, the mill shook from the vibration of the grinding stones and sailors loaded barrels of flour and whiskey aboard ships. Visitors to the site must have stared at the automated machinery in the gristmill in much the same way as we now gape at the latest innovations in computer technology.

At the time of his death in 1799, George Washington willed the gristmill complex to Lawrence Lewis, his nephew. By the 1850s the mill had fallen

into ruin, leaving little above ground for visitors to see. The distillery and other buildings of the once booming complex also slowly fell into disrepair and disappeared. The creek silted up over the years, so it is hard to believe it once had a major role in George Washington's business operations. In 1932, as part of the festivities honoring the bicentennial of Washington's birth, the Commonwealth of Virginia erected a reproduction of the gristmill on the site of Washington's original structure. Near the fairly accurate reproduction of the mill stands a large sycamore tree with a trunk approximately sixty inches in diameter. It is over 250 years old and was growing on the site when Washington made his daily visits, hitching his horse to the then much smaller tree. Located south of Route 1 on the east side of the Mount Vernon Memorial Highway, the mill is situated in a bucolic little park. It is a quiet reminder of George Washington's devotion to technology as he produced fine flour, barrels and good whiskey in Fairfax County.

From Centreville to Fame

In June 1861, the Confederacy moved its capital from Montgomery, Alabama, to Richmond, Virginia. With only one hundred miles separating the capitals of warring nations, Northern Virginia faced the distinct possibility of becoming a major battleground. However, at the time, nearly everyone in the split nation anticipated a very short war. The contempt each side held for the other's fighting ability was based on an ignorance of the geographical and military realities. One of the few individuals who thought otherwise at the time was an unknown colonel named William T. Sherman. He had lived in the South, and did not believe the coming conflict would be of short duration. Prior to the war, he had been the superintendent of the military academy in Pineville, Louisiana. When the state seceded, Sherman parted from his cadets in an emotional farewell and headed back to the North.

While thousands of young men were eagerly joining the Union and Confederate armies, Sherman brooded over the lack of understanding of the scope and magnitude of the coming struggle. Time would prove that he was one the few individuals in the country with a good grasp of the situation in those early war days. His dismal predictions would be accurate.

During July 16–18, 1861, General Irvin McDowell's Union army moved slowly from Washington to Centreville. The enthusiastic troops were poorly trained, lacked equipment and displayed sloppy marching discipline.

Perhaps these deficiencies would not matter. This army believed it was going to win a quick victory over the Confederates and end the war before the soldiers' enlistment time expired. Opposing them, an equally inexperienced Confederate army awaited attack along the banks of Bull Run. Prior to the battle, Sherman's brigade camped on the north side of Lee Highway on the slope leading up from the east bank of Big Rocky Run.

The first battle of Manassas quickly put a halt to the "easy victory" thinking so prevalent in political and military circles. Sherman retreated through Centreville with the despairing throng of defeated Union troops after the battle on July 21, 1861. He was an infantry colonel who had been in command of one of the last brigades to leave the field. Although no one in the retreating mob knew it that miserable Sunday night, Sherman was destined to become quite the visionary general. But being ahead of your time can have serious consequences. Because of his views on the duration and human cost of the war, many considered Sherman nearly insane. Due to the pressure caused by the constant rejection of his opinions, he suffered what today would be called a nervous breakdown. After recovering and returning to duty, Sherman served in subordinate roles in the western theater of military operations. In one of the best military decisions ever made, General Ulysses S. Grant placed Sherman in command of the army assigned to capture Atlanta, Georgia. The man who was once thought to be mentally unbalanced catapulted into national fame when his forces captured Atlanta on September 2, 1864. It had been a hard-fought campaign; Sherman's army had lost thirty-one thousand men fighting its way through north Georgia to Atlanta. Meanwhile in Virginia, although he virtually wrecked the Army of the Potomac in the ceaseless fighting, General Grant had accomplished what no previous Union commander had been able to do: he had pinned down Robert E. Lee's Confederate army in a siege at Petersburg, Virginia.

Now, a war-numbed, grieving nation wanted the fighting brought to a close. What to do next was the question. The fighting in Virginia was at a stalemate. In Georgia, Sherman's army was deep in hostile territory with ever-lengthening lines of supply. The Confederates, although severely battered, showed no sign of giving up. General Sherman had no intention of immobilizing his army by garrisoning Atlanta. He believed that the war must now be made so terrible that it would demoralize the civilian population supporting the Rebel armies with food and military supplies. His name would come to symbolize the terrible new doctrine of total warfare in which the destruction of the civilian economy is as important an objective as defeating the opposing military force.

The accepted military doctrine of the era stipulated that an army could not survive in hostile country without lines of communication and

supply. To attempt to do otherwise would bring disaster from starvation and attacks by enemy forces. When General Hood's Confederate army began moving into Tennessee to draw the Union forces out of Georgia, Sherman acted. He sent part of his army to halt Hood, and ignored the conventional wisdom by plunging deeper into Georgia. It was an audacious plan, and the country waited anxiously for the results. Either something new was in the making or Sherman's army was doomed.

General Sherman's forces had their own proud, distinctive style. Thousands in the ranks were under the age of eighteen; the majority of the lieutenants and captains in their early twenties; and most of the colonels were under the age of thirty. The six commanders of armies, corps and divisions averaged thirty-one years of age. They were also used to winning. These were the same troops that had chased the Confederates out of Kentucky, conquered most of Tennessee and chopped the Confederacy in two by prying open the Mississippi River. Then they had fought their way through north Georgia and into the vital rail and industrial center of Atlanta. They were cool and efficient in battle; discipline, however, was free-and-easy. General Sherman had long ago canceled all drills and reviews and reduced formality to a minimum. The troops fondly called him "Uncle Billy." He referred to them as "my little devils."

They also traveled light. Most of the men carried a blanket wrapped in a rubber poncho, a haversack, forty to sixty rounds of ammunition and the trusty rifle. Sherman's entire headquarters fit into a single wagon. Although the army was battle-hardened, lean and stripped to the bone, it had its softer side. The marching columns were swarming with pets. A squirrel rode on its master's shoulder. There was an owl in the mix and numerous dogs that rode on saddles, in wagons and on caissons. "Old Abe," the pet eagle of a Wisconsin regiment, rode out of Atlanta proudly perched on a cannon barrel.

When General Hood began fighting in Tennessee, there were few Confederate troops left to oppose Sherman in Georgia. With the rail, military manufacturing facilities and a good part of the civilian housing of Atlanta in smoking ruins, Sherman cut his communications with the North and his army of 62,000 marched east on November 16, 1864. They moved in two wings covering a sixty-mile front to confuse the Confederates. Their ultimate objective was Savannah on the Atlantic coast, over 250 miles away. Along the route, everything of economic significance that could support the Confederate war effort was to be destroyed. Sherman's marching order to the troops began with, "The army will forage liberally on the country during the march." The troops

tore up railroad tracks, heated them and twisted the rails into useless spirals. Some artistic wrecking crews got so good they twisted the rails into the letters "U.S." Buildings went up in flames. The charred chimneys that marked the army's passing became known as "Sherman's sentinels."

It was total war administered to a defiant population and it brought results. Confederate civilian and military morale plunged to rock bottom. Army desertions began to skyrocket as troops departed to care for starving families. The loss of transportation and manufacturing facilities turned an already bad supply situation into an intolerable one. Starvation and shortages began to ravage the Confederacy. On December 22, Sherman's army reached Savannah and linked up with Union naval units. That Christmas the North was jubilant. The army had not been destroyed as so often predicted by Confederate authorities and many other observers. Instead, it had sliced the Confederacy in two for a second time and inflicted fatal damage to South's war machine. To make matters worse for the Confederacy, General Hood's army was virtually destroyed in a battle at Nashville on December 15–16, 1864, by General George Thomas and the part of Sherman's forces sent to stop him. "Uncle Billy" Sherman had now been vindicated on all counts.

That should have been the end of it with the onset of winter and the end of the campaigning season. But General Sherman and his hellions were on a roll. After refitting in Savannah, the army swept into South Carolina, much to the disbelief of the Confederates who believed no force could travel over the soggy roads in winter. They took revenge on the first state to leave the Union by destroying virtually everything as they marched. Columbia, the state capital, burned on February 17, 1865. Charleston, with its communications cut by Sherman's forces, surrendered to the Union navy that had been attempting to capture it for nearly four years

The army was deep into North Carolina, heading for the Virginia line when the war ended. Raleigh was captured on April 13. In a delicious irony, Sherman accepted the surrender of General Joseph E. Johnston's Confederate army near Durham, North Carolina, on April 26, 1865. Johnston had been victorious at the first battle of Manassas, but much had changed in the years between 1861 and 1865. No one now questioned the military judgment of General Sherman. During the campaign, his army scorched and plundered a vast region of enemy territory and left a wrecked plantation society in its wake. The unknown colonel, who had begun his Civil War career in defeat as he retreated through Centreville on a Sunday night, had gone on to strike the deathblow to the Confederacy and rewrite military doctrine in the process.

WHEN THE ARMIES MARCHED IN CENTREVILLE

At the time of the outbreak of the Civil War, public health practices in the United States had been virtually static for nearly a hundred years. Those individuals fortunate enough to survive the ravages of numerous childhood diseases could expect to live to an average age of fifty-five. The army surgeons and civilian doctors who would soon be called upon to treat large numbers of soldiers knew little or nothing about the existence of germs and microbes. Their surgical practices were, by today's standards, crude and unsanitary. With the cause and treatment of diseases and infection rarely understood by medical professionals, it would not be the best of times to be wounded in a war.

Around noon on Thursday, July 18, 1861, General McDowell's Union army wearily trudged into Centreville in the ninety-degree summer heat. Later in the day, fighting flared at Blackburn's ford (where Route 28 now crosses Bull Run) as a Union force of approximately three thousand led by Colonel I.B. Richardson probed the Confederate defenses held by General James Longstreet. Soon the blood-smeared ambulances bearing the Union dead and wounded (eighty-three total) and those felled by sunstroke began arriving in the village.

As the sound of the heavy firing at the ford reverberated throughout Centreville, W.S. King, a Union army surgeon, rode out of Centreville

toward the sound of the firing and soon found the ambulances bearing the dead, wounded and disabled. He dispatched assistant surgeon D.S. Magruder to locate suitable buildings for hospital purposes. Dr. Magruder returned to the village and commandeered a "hotel, a church and a large dwelling" for use as hospital facilities. Among the first of the casualties to reach the surgeons was a seriously wounded soldier. The stunned doctors noted he "had his face shot away completely." In the ensuing chaos, one contrary regimental surgeon ignored two wounded soldiers and let them remain lying in an ambulance for hours because they were not from his regiment. He treated them only after being ordered to do so by W.S. King, who outranked him.

During this first encounter with the realities of war, the doctors encountered great difficulty in obtaining water for drinking and medical use because the large number of newly arrived, thirsty troops created a severe water shortage as they quickly emptied the wells in Centreville. To ensure access to water, guards had to be posted at certain strategic wells to protect the critical water supplies used by the medical staff.

It is unclear which Centreville structures were the first to be turned into hospitals on that long ago July day because Dr. King did not name them. He spent July 19 and 20 supervising treatment of the wounded and arranging for additional medical supplies to be shipped from Washington via Fairfax Station. All the wounded from the Blackburn's ford fight able to withstand the rigors of travel were moved to Fairfax Station on July 20 and sent back to Alexandria and Washington.

As the army prepared to go into battle, assistant surgeon D.S. Magruder took possession of "a stone church situated in a grove of trees directly on and to the right side of the road." Men were set to work removing the seats from the church and whatever blankets were available were stacked in readiness on the floor. Buckets were collected and filled with water, an operating table was improvised, instruments readied and hay brought in from the nearby fields to serve as bedding. As the preparations were hurried along, Union army nurse, Emma Edmonds who must have had a premonition of what was coming, wryly noted it was "a church which many a soldier will remember, as long as memory lasts."

About two hours after the first battle of Manassas began on Sunday, July 21, 1861, the Stone Church was filled with wounded and Magruder took over three other unoccupied buildings "situated about seventy-five paces farther down and on the opposite side of road." These buildings were also soon filled and the incoming wounded were placed in the grove of trees around the Stone Church. Although they remained in the open,

they would at least be afforded the benefit of the shade cast by the trees until the doctors could attend them.

After being routed, the Union army left behind many of its 1,100 wounded and another 1,300 missing men. On July 25, a captured Union surgeon noted that a number of wounded men remained in Centreville. On or about July 28, many of the captured wounded were moved to Manassas Junction by the victorious Confederates and loaded into freight cars for transport to Richmond. The trains transporting the wounded were given no special priority and, as they were often switched onto sidings for long periods, took as long as two days to reach Richmond. Without proper food, adequate water or medical treatment many of the wounded soldiers died during the agonizing trip in the sweltering rail cars.

A little over a year later, the armies returned to fight again on the same ground. During the second battle of Manassas, the Union army established a medical depot at Centreville and once again utilized the churches and other buildings in the village as treatment centers. The medical inspector assigned to General Pope's army established his headquarters at Centreville and directed the affairs of the transport service and medical department from the village. By Sunday, August 31, 1862, the village was again filled with wounded, and the defeated Union forces were dourly regrouping along the Centreville heights.

The Union army had over eight thousand wounded and another four thousand men listed as missing. On September 1, 1862, under a flag of truce, Union surgeons, medical attendants and volunteers began collecting some of the wounded left on battlefield. Those fortunate enough to be collected were promptly paroled by the Confederates and moved to Centreville. As the Union army withdrew, a large number of the wounded appear to have been left behind in the village. The medical situation was so unfavorable at Centreville that on September 4, one of the remaining Union surgeons sent a desperate communication to General Lee's headquarters begging for food and ambulances. The Confederates acknowledged the gravity of the situation and agreed to share food and captured medical supplies with the Union doctors who had remained behind.

On September 6, as Lee's weary army moved deeper into Maryland headed for yet another epic battle, a column of ambulances came out from Washington to pick up the Union wounded in Centreville. By that time, the Confederates were gone, having evacuated over six thousand of their own wounded by railroad to the receiving hospital at Gordonsville, Virginia, where they were treated and forwarded to hospitals in

Richmond, Lynchburg and Charlottesville. As with the Union wounded the year before, many of the Confederates died during the trip on the railroad. The Rebel wounded had been laid on the bare floors of the rail cars like bags of grain, and no one thought to send attendants with them to provide food and water. There was an embarrassing incident in Lynchburg when a train arrived during the night and was allowed to stand at the depot unattended, the wounded receiving no care.

As an eerie quiet settled over the war-ravaged northern Virginia countryside during that hot summer, the blood-spattered buildings of Centreville waited once again to be reclaimed from their brush with history by an ever-dwindling number of inhabitants.

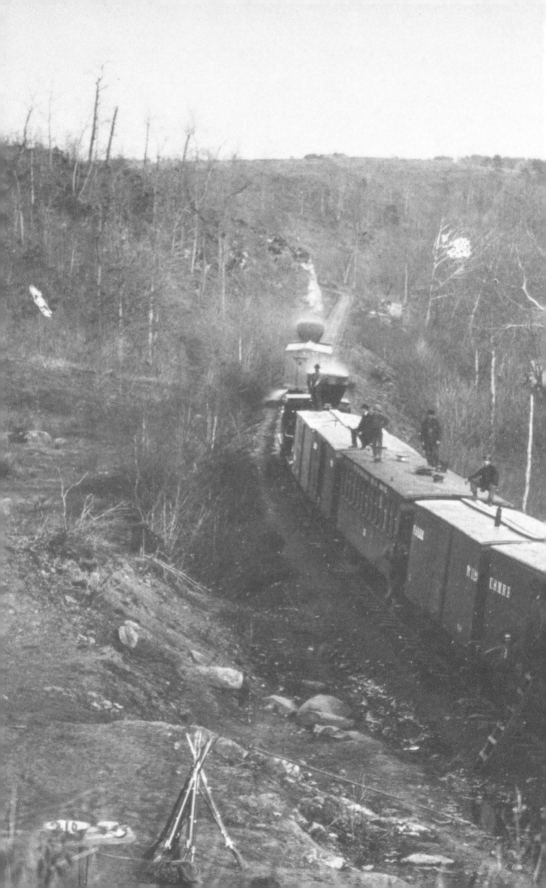

Part Three

A WARTIME SKETCH

During the Civil War, photography equipment was not developed well enough to permit the taking of anything other than still pictures. Because of the long exposure time required to make a print, photographers were unable to photograph battles. Then as now, a good action picture sells newspapers. In order to provide illustrations of Civil War battles for the papers, a group of combat artists traveled with the armies. Their field sketches were rushed to engravers located in the main office, where they redrew the scene on wood. The inked sections were then cut away and used to make a metal impression that printed the scene on paper.

Rated among the best of the combat illustrators was Edwin Forbes (1839–1895) who drew for Frank Leslie's *Illustrated Newspaper*, a weekly publication. At one period in the war, the paper had a circulation of 150,000. The realistic Forbes wanted readers to understand what it meant to be a soldier in the Union army, and his drawings accurately portrayed the grim reality of military life. He was twenty-three years old in 1862 when he went to war as a combat artist. He accompanied the Union armies in Virginia from 1862 to the autumn of 1864. It was a rough life. The reporters and artists lived with the army and were dependent upon it for food. They were routinely exposed to hostile fire, foul weather, disease and possible capture.

During August 1862, Forbes was with General John Pope's Union army when it was defeated at the second battle of Manassas (Bull Run) on August 29–30. He watched the battle unfold and accompanied the army on its retreat to Centreville. He stood by the side of the Warrenton Pike (Route 29) in the growing darkness and watched the dispirited troops as they passed by. Tired and despondent, he then rode through the rain into Centreville where he crawled under an overturned wagon for shelter. It was dark by then and he found several soldiers already under the wagon. He lay down alongside one who mentioned that he had been severely wounded in the face. Forbes gave him his rubber poncho, and told him how sorry he was to learn about the wounding. The soldier replied, "I don't mind being wounded so much, but to be hit in the face will so disfigure me that the girls will never look at me again."

Forbes left before daylight and never had a chance to see the soldier's face. He often recalled the soldier's odd reply, and wondered if his apprehension came true or if his wound became a badge of honor, more attractive to the girls than an undamaged face. Nearly thirty years later, Forbes still remembered that terrible night at Centreville and the conversation with the sad soldier. He included his recollection of the incident in his memoir, which was published in 1890.

The next day, August 31, 1862, Forbes did a drawing of part of the Union army at Centreville, which he did not include in his memoir. Perhaps it was only a quick sketch that he did not consider good enough to publish. Or its utility may have been overtaken by events since it was a hectic time. The Union army would soon be heading for Maryland to block Confederate General Lee's invasion at the battle of Antietam. Forbes would certainly have been busy with that monumental struggle which overshadowed the army's short stay at Centreville.

Even though he paid little attention to the drawing after the war, Edwin Forbes has left us an accurate portrait of military events as they transpired at Centreville on a hot August day, 134 years ago. Based on the details of the sketch, it is even possible to make a judgment as to the present location of the scene. Although it cannot be verified with 100 percent certainty because of the changes development has brought to the landscape, I believe Forbes was on the west side of Little Rocky Run near what is now Lee Highway (Route 29) and was looking west when he took up his pencil and began to draw. The large fortification with the flag in the center of the sketch is part of the Centreville fortification line built by the Confederates during the winter of 1861–62 and occupied by Union forces in 1862 and 1863. It is most likely "Artillery Hill" which

stood where Lee Highway and Old Centreville Road now intersect. The barely visible fortification at the left side of the sketch could be a smaller fortification that stood near what is now the Pickwick Square Shopping Center. It was also constructed as part of the Confederate defense line.

The flag flying over Artillery Hill matches that of the First Division, III Corps of the Union army. The First Division's battle flag consisted of a red diamond on a white background. The unit was commanded at the time by General Philip Kearny. On September 1, 1862, he led the division from Centreville into battle at Ox Hill (Chantilly), where he was killed.

Why did Forbes decide to draw the sketch? We will never know his reasoning. Perhaps he was attempting to capture on paper the melancholy state of General Pope's army after defeat. Whatever his reason, he has left us a poignant reminder of the time war swept over the Centreville region.

WHEN UNION MILLS
STOOD PROMINENT

In 1861, Union Mill Road was a dirt wagon track used primarily by local farmers. It ran south from Braddock Road, and after meandering through the countryside on the east side of Little Rocky Run for nearly four miles, it crossed the Orange and Alexandria Railroad tracks. Situated next to the road and tracks was Union Mills Station, one of the original stops on the railroad line. Located near Popes Head Creek close to its confluence with Bull Run, Union Mills was, along with Sangster, Fairfax and Burke, among the first stations opened when the Orange and Alexandria Railroad began operation in the early 1850s. This far-reaching new form of transportation technology helped expand the markets for the region's farm products and drastically reduced transportation and travel costs.

When the Civil War began, the railroad was suddenly transformed from being a benign mover of civilian freight and passengers into a military implement of war. Almost overnight, its benefits changed into hardships for those who lived near the tracks. Union Mills was no longer a quiet country station; it became a place with a high degree of military significance. It was so important that U.S. President Abraham Lincoln and Confederate President Jefferson Davis knew all about Union Mills. Generals such as Joseph Johnston, Robert E. Lee, Stonewall Jackson, John Pope, George Meade and thousands of the soldiers who served

with them also became familiar with the location. During the first year of the war, the Confederates made the Union Mills area part of the defense line that ran from Centreville to Manassas Junction. After the Confederates departed in early 1862, Federal troops were stationed at Union Mills to protect the Bull Run railroad bridge and they expanded the fortifications and constructed a number of new ones. As the armies marched and countermarched along the railroad line, the defenses were further modified as they changed hands. Due to the difficulties created by the constant guerrilla raids on the railroad, Union authorities ordered the removal of all inhabitants from a swath several miles wide on both sides of the tracks later in the war.

As the war got underway, it became clear to President Lincoln and his advisors that it was going to be impossible to guard long stretches of track against attack by Confederate raiders. If the rail lines could not be protected from damage, they would have to be repaired and returned to service in the shortest time possible. In April 1862, Herman Haupt was called to Washington by the Lincoln administration and asked to fix the vexing problem.

As Haupt went to work, it was at places such as Union Mills that his highly organized and specialized repair crews honed their skills as they struggled to keep the Orange and Alexandria line running. The procedures Haupt developed to replace bridges, track and just about everything else involved in keeping a railroad operating allowed the United States Military Railroad (USMR) to keep vital rail supply lines functioning. The USMR established a base of operations at Union Mills. It was a facility to service equipment and store replacement parts for railroad rolling stock, water tanks, prefabricated bridges, ties and rails.

Down the tracks west of Union Mills, the Union army established a massive quartermaster depot at Manassas Junction that contained a square mile of warehoused army supplies. On the depot's two spur-railroad sidings, each a half mile long, were parked over a hundred boxcars. When the telegraph line to Washington suddenly went dead in late August 1862, Union commanders had no way to know that it was General Stonewall Jackson's army corps that had suddenly emerged out of nowhere and pounced on the supply base. Thinking that it was no more than an annoying cavalry raid, they rushed a brigade of New Jersey troops by rail to the vicinity of Union Mills with the objective of holding the railroad bridge and possibly driving away the raiders. Having no idea of what they were getting into, the unseasoned and eager troops disembarked from the trains and marched west. When they ran into Jackson's veterans they were routed,

their commander and approximately 135 others killed or wounded and another 200 captured. The panicked survivors fled eastward, abandoning the bridge and bringing with them the shocking news that there was more than Rebel cavalry at the supply depot.

To prevent another rude interruption of the depot's looting and to disrupt rail traffic, Jackson ordered the bridge destroyed. When the Confederates pulled out during the night of August 27, 1862, they left behind them a sky reddened by burning warehouses, rail cars and exploding ammunition dumps. The Union supply depot had been obliterated, never again to be rebuilt. Haupt's crews went to work and reconstructed the Bull Run railroad bridge, only to see it quickly lost again after the Union army retreated into Washington in early September following the battle of Second Manassas.

Union Mills continued to serve as a major USMR depot until the Union army ceased using the Orange and Alexandria line late in the war. A new stop named Devereux Station was established on the railroad line less than two miles east of Union Mills at some point during the conflict. It began as a place to load and ship the wood burned in steam locomotives and the timber needed for military construction projects. The station's name was changed to Clifton in the late 1860s. After the war ended, Union Mills faded from the maps, its civilian functions most likely absorbed by the newer station at Clifton. With the control and repair of the railroad line no longer a military necessity, Union Mills had lost its last reason for existence. The stretch of shiny track running west out of Clifton is the only memorial to the time when Union Mills was a location of real consequence. The railroad bridge over Bull Run was one of the most famous bridges in the United States. It was sketched and photographed repeatedly, appearing at one time or another in most of the major Northern newspapers. It was the scene of much action, having been destroyed and rebuilt seven times during the war. The abutments of the original railroad bridge still stand next to the modern bridge. It is an easy place to visit via the regional park trail that runs along Bull Run. It is only a short hike from the Hemlock Overlook Regional Park entrance on Yates Ford Road.

A Fairfax County
Farmer's Legacy

Because of his epic contributions to the founding of the United States, George Washington's memory is honored by most Americans. Nearly everyone possesses one or more of his portraits; it graces the millions of one dollar bills in circulation. Washington is remembered for his unflinching leadership when he commanded the ragged, hungry and often unpaid Continental army during the American Revolution. In a wide-ranging war that was fought against British Regulars and as a guerrilla campaign on the western frontier, Washington directed the Colonial forces in the desperate struggle to gain independence from the British Crown. Working with testy French allies, Washington labored to keep the shaky coalition together until victory was won.

The mails were slow and communications were poor. Having to function in a time when there were no opinion polls or public relations firms, George Washington had to rely on his strong internal compass for guidance as he waged a difficult war with one of the world's most powerful empires. During the conflict, which probably never had the active support of more than 35 percent of the American population at any given time, Washington turned down the offer by his disgruntled soldiers to seize power and make him America's king or dictator. After independence had been won, Washington quietly resigned as commander of the army in December 1783.

As the fractious, newly independent colonies groped through a period of economic and political chaos, Washington served as a member of the May–September 1787 convention in Philadelphia that produced the United States Constitution. It has been said that the duties of office of the president of the United States were crafted by the members of the Constitutional Convention to precisely fit the personality of George Washington. After serving as the first president of the United States, Washington voluntarily stepped down at the end of his second term. It was a move that shocked other world leaders in a time when no one gave up political power short of death or revolution.

All in all, it was not a bad record of accomplishment for the one-time surveyor from Virginia who saw his hopes for a commission in the British army dashed during the French and Indian War. The enormous military and political legacies left by Washington have obscured his lifelong interest in science. The death of his half-brother, Lawrence, propelled George Washington unexpectedly into a new life as a farmer in the 1750s as he took over the management of Mount Vernon, a plantation of 2,126 acres. Although the farm was declining in fertility because the incessant growing of tobacco depleted the soil, Washington discovered he had a genuine love of farming. Quite happy in his new home, he eventually increased the size of the property to 8,000 acres, of which approximately 3,200 were under cultivation.

Even though Washington owned a large tract of land, much of it would be considered to be of mediocre quality today. Around 1765, he reduced his tobacco acreage by switching to wheat and corn production. His crop production totals were low when judged by modern standards. Washington's corn crop averaged only fifteen bushels per acre. Although the sciences were in their infancy, the self-taught Washington was a scientist at heart, believing in honest observation and experimentation. He undertook agricultural experiments as he tested over sixty crops for suitability and profitability. George Washington slowly taught himself how to combat the soil exhaustion that had become a major problem in Virginia. Often rising at 4:00 a.m., he averaged fifteen miles per day on horseback as he made the rounds of his farms. Over time, his efforts made Mount Vernon successful as he experimented with fertilizer, animal manure and marl (natural lime). He dredged river mud in a test to determine if it could be used as a fertilizer on his fields. Washington developed a sophisticated crop rotation cycle, planting grasses, clover and buckwheat to improve the soil. In a procedure unusual for the time, Washington left areas along the banks of creeks in pasture to prevent soil erosion.

Washington's interest in the production of fruits and flowers led him to greatly enlarge the gardens and orchard as he sought to increase yields. He was an excellent horseman, a devoted breeder and trainer of horses. He had 130 of them on his farms, keeping his favorites until they died of old age. His diverse plantation also produced quality hogs, chickens, turkeys, swans, ducks and geese. The pasture fields supported 600 sheep, but Washington had poor luck in his cattle raising endeavors.

After two hundred years of adding to agricultural knowledge, we know that the soil of the region is best suited to corn, soybeans, mixed hay and small grains. Washington had to learn these lessons by observation and experimentation because the agricultural practices that had been successful in England often failed in the harsher climate of Virginia. In England's cooler, temperate climate, wool producers could produce eleven pounds of wool per sheep. Following the same procedures in Virginia, Washington was lucky to obtain three pounds. He was engaged in a struggle with land that often dealt him many disappointing setbacks. To make matters even more discouraging for Washington, when he was away from Mount Vernon, his unthinking and careless overseers let much of what he accomplished fall by the wayside.

As Washington doggedly worked to expand his store of knowledge, he constantly sought advice from the leading scientists of the age, writing every evening after the conclusion of the day's labors. A prolific writer, Washington produced an estimated 26,000 to 40,000 pieces of correspondence during his lifetime. Far-sighted, Washington thought America one day could become "the storehouse and granary for the world." In a 1794 letter he wrote, "I know of no pursuit in which real and important services can be rendered to any country than by improving its agriculture, the breed of useful animals and other branches of a husbandman's cares."

Unfortunately, few others in Virginia shared Washington's thirst for agricultural knowledge and preserving farm productivity. As a consequence, between 1817 and 1830, the value of Virginia's farmland fell from $207 million to $90 million. Between the American Revolution and 1850, approximately one million Virginians moved west as a result of the cycle of land ruination that Washington had hoped to halt. It would be over one hundred years before the prudent agricultural practices so painstakingly tried by George Washington would become widely accepted by America's farming community. As such, George Washington deserves a measure of recognition for being an agricultural visionary. Despite his success in other fields of endeavor, Washington would never

have been insulted by being called a farmer. He may have considered his contributions to the expansion of agricultural knowledge to have been of more lasting significance than his prodigious political and military achievements.

A NATION'S INNOCENCE
DIED AT CENTREVILLE

When Virginia seceded from the Union in 1861, the Confederacy, in June of that long ago year, moved its capital from Montgomery, Alabama, to Richmond, Virginia. With only one hundred miles separating the capitals of the United and Confederate States, Northern Virginia was destined to become a fiercely contested land. The nation had broken apart over a complex series of economic and moral issues involving the growing industrial power of the North, the resulting shift of political power from the Southern states and the divisive issue of slavery. After Abraham Lincoln won the presidential election of 1860, the planter class of the South, believing their vital interests at stake, decided to opt out of the Union and forge a new nation. That raised the question of what the Union had stood for in the past, and what it was going to be in the future. The result was war and thousands of young men were eagerly joining the military forces of the United and the Confederate States of America. A large number of them were destined to never see their homes again. By the end of the war, more than 620,000 soldiers had lost their lives to bullets or disease.

A Union army commanded by General Irvin McDowell reached Centreville on July 18, 1861. As they lounged in their camps, the troops carried with them the last vestiges of a national innocence that would,

in a short time, be destroyed on the battlefield. Nothing would ever be the same again for these soldiers or the nation. Awaiting them, on the opposite side of Bull Run on an eight-mile front stretching from Union Mills to the Stone Bridge on the Warrenton Turnpike (Route 29), was an equally green and poorly supplied Confederate army.

On July 18, General Daniel Tyler, commander of the First Division, received orders from General McDowell to probe the Confederate right flank, which was thought to be the strongest part of the line. At Blackburn's Ford, where Route 28 now crosses Bull Run, the troops of Colonel Israel B. Richardson's Fourth Brigade collided with the Confederates. The topography of the area favored the Union attackers because the north bank of the stream was much higher; it provided an excellent position for artillery. However, it was not going to be as easy as it looked because the Rebel troops were commanded by a newly arrived general named James Longstreet. He was holding the ford with a brigade consisting of three Virginia regiments. Longstreet had nearly 1,200 men in battle formation when the Union forces opened with artillery fire and a section of the infantry advanced down the slope toward the ford, firing as they moved.

A number of the Virginia troops, unfamiliar with enemy fire, broke from the ranks and ran for the rear. Displaying the traits that would make him one of the Confederacy's best generals, Longstreet moved among his men, a cigar clamped in his mouth, and, calmly ignoring the zipping bullets, stabilized the battle line. The Virginians rallied and repulsed the attack.

The Union gunners moved forward two cannon and fired canister shots that sliced away the tree branches above the Virginians' heads. Colonel Richardson then ordered the entire Union brigade forward to the attack. When they came into range, Longstreet's battle line exploded with return fire. His presence was noted everywhere along the firing line, coolly giving orders and steadying the raw troops. On both the Union and Confederate sides, small groups of men drifted to the rear, drained of courage and cured of their romantic notions of war.

In response to Longstreet's request for assistance, Confederate infantry and artillery reinforcements began to arrive. As he was overseeing the deployment of a newly arrived infantry regiment and riding in front of its ranks, the regiment's officers made a big mistake; they gave the order to fire. Longstreet dived from his horse to the ground, a barrage of shots flying overhead. Only when he stood up did the troops realize that he had not been hit. The comments made by the irritated general to the unit's mortified officers were not recorded. The reinforcements

blunted the attack, and Richardson's infantry force slowly withdrew. The opposing artillery units continued to duel; the firing could be heard in Centreville until dark.

The brutal little fight was a harbinger of things to come. The Confederates suffered sixty-eight casualties, the Union troops lost eighty-three killed or wounded. The Union wounded were taken back to Centreville, and the little village got its first taste of war as the surgeons appropriated buildings for medical use. The small number of casualties, despite the high volume of fire and length of the engagement, was due to the poor marksmanship of the combatants. New troops had a tendency to always aim high. Time and combat experience would correct the habit with devastating results. In later battles, the casualty rate would approach 25 percent.

At the fight for the ford on Bull Run, James Longstreet began a career that would make him one of the Confederate army's most capable generals. He was promoted to major general while the army was at Centreville during the winter of 1861–62. Although one Confederate observer said life at Centreville consisted of "monotony and miserable inactivity, measles and typhoid fever," Longstreet's headquarters were a center for socialization. His enjoyment of a good time, a good meal and a drink brought him many friends. His military scorecard continued to improve on his second visit to the region. By then, he was a corps commander under General Lee, and he delivered the attack that broke the Union army at the second battle of Manassas in August 1862. With Longstreet in command of his army's First Corps and Stonewall Jackson in charge of the Second, it appeared for a time that General Robert E. Lee had assembled an unbeatable group of subordinates to carry out his audacious plans. The combination worked well up to the time Jackson was killed. Although Longstreet disagreed with Lee's decision to fight at Gettysburg, he was later unjustly blamed by other Southerners for the Confederate failure there. Wounded at the bloody battle of the Wilderness in May 1864, he recovered and returned to duty later in the war. Longstreet served the Confederacy to the bitter end. He was with the Confederate Army of Northern Virginia when General Lee surrendered it at Appomattox Court House in April 1865. Always interested in the welfare of his troops, he was the only officer of his rank to surrender with the troops under his command.

Guerrilla War

Confederate General Robert E. Lee was looking for ways to impede the Union forces operating against his poorly supplied and outnumbered army. To accomplish this end, in January 1863 he approved an order sending a lieutenant named John S. Mosby to operate behind the Union lines in Northern Virginia. Mosby's mission was to tie down troops and disrupt Union supply lines. Beginning with fifteen men, Mosby launched a campaign that made life miserable for Union forces in Northern Virginia during the last twenty-eight months of the war. In the process, he became the most effective leader of irregular forces produced by the Civil War. A 125 square mile section of Northern Virginia became known as "Mosby's Confederacy." Stretching from the gates of Washington to the Blue Ridge, it was a region in which neither Union supplies nor soldiers were safe. Mosby's raids forced the Union army to deploy a large number of soldiers, who could have been put to better use, as guards for camps, railroads and wagon trains.

Although he weighed only 128 pounds and stood five feet six inches tall, Mosby was a true leader. One observer noted that when angered, Mosby's glare could chill a man to the bone. He was no stranger to violence. At the age of nineteen, while a student at the University of Virginia, he shot a man during a brawl. Sentenced to a year in prison, he

served seven months before being pardoned. Mosby put the time spent in jail to good use by studying law; he was admitted to the bar several months after his release.

Although opposed to secession, Mosby joined the army after Virginia withdrew from the Union. He was serving with General Stuart's cavalry at the time he was detailed to begin a modest partisan campaign in Loudoun County. It was the beginning of raids, ambushes and attacks against Union forces in an area stretching from the outskirts of Washington to the Shenandoah Valley. John Mosby had a natural instinct for guerrilla warfare. He believed that an enemy's rear was the most vulnerable section of its lines. "Mosby's Rangers", as they were popularly known, were officially titled the Forty-third Battalion of Virginia Cavalry. It was a detached unit, under military discipline, with Mosby reporting directly to General Stuart, Lee's cavalry chief. After Stuart's death in May 1864, Mosby reported directly to Lee. He was the only commander of a unit smaller than a corps to do so. For his services to Lee's army, Mosby was eventually promoted to colonel.

The popular belief that Mosby commanded a small force is incorrect. Over 1,900 men served with Mosby between January 1863 and April 1865. Of these, approximately 80 percent were local residents. It was not easy duty; the Rangers suffered a casualty rate of 35 to 40 percent. The Federals captured at least 477, and 25 are known to have deserted. Mosby's force was dependent upon the support of the local population for survival. The locals provided food, clothing and safe houses with hiding places under floors and in walls. They also operated signal stations. A harmless blanket draped over a fence was a signal for a group of Rangers to gather at a prearranged location. In rain and cold weather, the guerrillas wore captured federal overcoats. This led to the charge that they hid their identities to deceive pursuing Union forces.

It was a campaign of constant small fights in which combat was measured in minutes, not hours. Mosby considered sabers useless and ordered his troops to carry at least two pistols; some carried as many as four. Extra loaded revolver cylinders were carried to reduce loading time and permit a rapid continuation of fire. Mosby's tactics were governed by the simple rule, "If you are going to fight, then be the attacker." In early January 1863, Mosby struck the Union picket line near Herndon Station. Union outposts near Centreville, Vienna, Chantilly, Jermantown and Alexandria also felt his lightning jabs. Wagon trains were attacked near Annandale and Fairfax Court House. Mosby was soon able to report that "Union commanders now do not keep their pickets over a half mile from camp." As a result of his raids, large numbers of Union cavalry had to be detailed to guard

supply trains and a heavy guard had to posted around Union camps at night. The constant attacks by Mosby's Rangers also hardened the attitude of the Union soldiers. A Michigan trooper expressed this clearly when he said, "The guerrillas had taught us to expect an enemy to fire at us from every bush or fence corner on the road."

Fame and official recognition followed Mosby's raid on Fairfax Court House on March 9, 1863. With only thirty men, he swept through the lines and captured Union General Stoughton. He then sped to safety with his captives: the general, an Austrian baron, two captains, thirty privates and fifty-eight horses. Upon learning that General Stoughton had been captured in bed, Abraham Lincoln remarked, "Well I am sorry for that. I can make new brigadier generals, but I can't make new horses."

Throughout the late summer and autumn of 1863, Union General Meade operated against Lee's army along the Rapidan River. His main line of supply was the Orange and Alexandria Railroad. Mosby hit the rail link hard. The constant attacks by Mosby, then called the "Gray Ghost," helped the Union cause in one way desertions were down because soldiers were afraid of being captured by Mosby's forces. As Lee's supply situation worsened, Mosby began sending captured material and the food, horses and cattle taken from pro-Union families to Lee's army. On August 24, while attacking an army horse herd moving from Alexandria to Centreville, Mosby was shot in the thigh and groin. The wound disabled him for a month.

In August 1864, Union General U.S. Grant gave Philip Sheridan the assignment of destroying the Shenandoah Valley, the major food source of Lee's army and an avenue of Confederate invasion. As a welcome to Sheridan, on August 11, Mosby attacked a Union supply train near Berryville. He captured one hundred wagons, six hundred horses and a $112,000 army payroll. That was big money in the days when a soldier made $15 a month.

Mosby's Rangers and John McNeill's Second Virginia Cavalry, which operated in northwest Virginia and the Shenandoah Valley, constantly attacked Sheridan's supply lines, which led back to Martinsburg. The guerrilla threat posed a major logistics problem for Sheridan because it took a force of 1,500 cavalrymen to safely guard a train of two hundred supply wagons. Although the past Union attempts to conquer the Valley had been failures, General Sheridan defeated Early at Winchester and pushed the Confederates south to the vicinity of Staunton. In late September 1864, Phil Sheridan halted his advance and deployed his cavalry corps across the Valley. The twenty-mile wide line of troopers

began moving slowly north, driving livestock ahead of them and burning everything else. The red in the valley that autumn was from burning homes, barns and mills, not the fall foliage. For ninety-two miles between Staunton and Winchester, Sheridan's troops left nothing but smoking ruins. There was anger in the air, a rage born of bushwhacking and throat slitting. As they moved, Sheridan's troops took their revenge on the "cowardly nightriders who shot people in the back and then faded back into a civilian population that hid and fed them." In such an environment, many a private home went up in smoke even though dwellings were supposed to be spared. Mosby issued orders to kill all Federals caught burning houses and barns. To be captured by Mosby's men meant certain death as the Confederates shot or hanged those caught burning or foraging. After a skirmish in the Luray Valley with Mosby's Rangers on September 25, 1864, Union troopers became convinced that one of their officers had been murdered after surrendering. In retaliation, Sheridan had six of Mosby's men executed near Front Royal. In reprisal, Mosby executed six federal prisoners.

One of Sheridan's favorite staff officers was Lieutenant John Meigs, a topographical engineer and the son of army Quartermaster General Montgomery Meigs. On October 3, 1864, while traveling in a rainstorm between army camps in the vicinity of Harrisonburg, he was shot and killed by guerrillas disguised as federal troops. Sheridan unloosed his famous temper. In retaliation, he ordered the village of Dayton and every house within a five-mile radius burned. However, before much damage was done, he cooled down and countermanded the order.

Having smashed General Early's Confederate army at the battle of Cedar Creek on October 19, 1864, General Sheridan decided the time was ripe to cripple Mosby's home base. In late November, three thousand Union cavalrymen poured into Mosby's Confederacy. Their objective was to destroy all forage and subsistence between the Bull Run Mountains and the Shenandoah. Barns, corncribs, smokehouses and harvested crops were burned. They removed all horses, cattle and sheep. A Massachusetts officer said, "It was a terrible retribution on the country that had for three years supported and lodged the guerrilla bands and sent them out to murder." In one day, his troops burned 150 barns, 100 haystacks and 6 flourmills.

In December, Mosby was shot in the stomach. He was not taken prisoner because the Union soldiers failed to recognize him and believing his wound to be mortal, left him in a house to die. Mosby recovered, and in February 1865, he was in Richmond where he conferred with Lee

and sat for a portrait. He also enjoyed the praise and adoration of the public because he was on the way to becoming a legend. By then the war was drawing to a close and there was little left for Mosby to do. On April 9, 1865, the day Lee surrendered, the Rangers fought their last action. Their camp near Burke Station was overrun by a tough Illinois outfit that chased them all the way to Bull Run. On April 21, near Salem, Virginia (now Marshall), Mosby disbanded his group and bid them a tearful farewell. After the war, he practiced law, served as consul in Hong Kong and as an attorney in the U.S. Justice Department. He died at the age of eighty-two in 1916 and was buried at Warrenton.

WHEN NEW BATTLE FLAGS PROUDLY FLEW AT CENTREVILLE

In the days before radio communications made the job easier, military commanders had a difficult time telling one unit from another on a battlefield. During the Civil War, the flags carried by the various units were the most important means of identifying the troops as they moved across the landscape. Although unit identification was the essential military function, battle flags also became powerful badges of military affiliation and revered symbols of the state and country the soldiers were fighting to protect. So strong was the symbolism attached to Civil War battle flags that the loss of one to the enemy during an action was considered to be dishonorable, unless no one in the flag-losing unit remained alive. On the other hand, to capture the enemy's colors was the ultimate battlefield triumph because it signified the humbling of the foe. To carry one of a fighting unit's battle flags was both a position of high honor and a deadly enterprise because the flag bearers of Civil War armies were conspicuous. Because of the high degree of visibility, the job of flag bearer carried with it a high probability of getting shot.

As the first battle of Manassas raged across the countryside on Sunday, July 21, 1861, Union and Confederate commanders came to realize that they had a major command and control problem on their hands. It was almost impossible to tell friend from foe because many of the opposing units

wore uniforms of the same color and the Confederate national flag, with its blue field containing seven stars and alternating three stripes (red, white and red), was easily mistaken for the United States flag when hanging limp on the flag staff. In the smoke and confusion of that scorching July day, friendly units fired at one another by mistake and failed to fire on enemy formations because of the difficulty in ascertaining which side the troops were on. In the afternoon, the Union attack began to fall apart after a crack artillery outfit was ordered to hold its fire while its commanders tried to determine the status of an infantry force advancing through the battle smoke toward the waiting gunners and loaded cannon. Waiting to fire proved disastrous; the artillerymen were decimated by the volleys of the advancing blue-uniformed infantry that turned out to be Confederate. The gunners went down in heaps, the battery horses were killed and the crewless cannon went out of action as the Rebel force swept over the position.

Later in the summer, Confederate Generals Johnston, Beauregard and Smith met and decided to create a purely military flag for the army. It would have to be a distinctive flag, one that could not be mistaken for any other flag then in use, state or national. After much discussion, the generals settled on a design provided by Congressman William Miles of South Carolina, who was serving as an aide on Beauregard's staff. Miles had originally submitted his design to the Confederate government as a proposal for the Confederate national flag, but it had been rejected. During discussions with the generals, Miles altered his original design by adding stars for the additional states that were now considered to be part of the Confederacy. The generals liked his revised design and accepted it. This unofficial battle flag would resolve the troubling flag identification problem. After new flags were issued to the army's units, no one would have any difficulty identifying the forces carrying the new battle flag as Confederate.

In order to make the army's unofficial battle flag easier to manufacture and carry, it was designed in a square shape, forty-eight inches for the infantry, thirty-six inches for artillery and thirty inches for cavalry. It consisted of a blue St. Andrews cross with thirteen stars emblazoned on a red or pink field (depending on the color of the cloth available) and bordered by a narrow stripe of white. The first of these new flags, sewn by ladies in Richmond, reached the generals in autumn 1861 and were accepted before massed troops at a ceremony at the fort named Artillery Hill in Centreville, located near the present intersection of Route 29 and Old Centreville Road.

As more of the new battle flags arrived during the relatively quiet autumn, the generals presented them to the troops in elaborately staged ceremonies. In one such event observed by a Richmond newspaper

reporter writing under the name of "Kiawah," Generals Johnston, Beauregard and Van Dorn presented flags to a dozen regiments on December 2, 1861, in a field south of Centreville on what was then part of Yorkshire plantation. The reporter's written commentary reflected the passionate idealism still widespread during the first year of war. "The brilliant military display of yesterday shone out in striking contrast against the leaden colored sky which has overhung the camps near Centreville for several consecutive days." Obviously impressed by the grand display of military pageantry, he continued, "The ceremony was a novel one; arms were burnished, guns polished and caissons subjected to a scrupulous scrubbing. Generals with stars, on richly caparisoned horses, galloped from point to point, and as the hour drew near, column after column could be seen crossing McLean's Ford, on Bull Run, and wheeling into line in the Old Fields on the southwest side."

He also accurately summarized the generals' reasoning behind the need for a distinctive battle flag. "Think of England preparing for battle without the Red Cross of St. George, or France substituting any standard for the Tri-color, then judge how singular the making up of a new flag to take the place of the one recently adopted by our Congress. Ask for a reason for this inconsistency, you have it in the language of General Beauregard, who recently stated that he never wished to see the Stars and Bars on another battlefield. The General is right; he wants to know, by the colors, what column approaches; and this, it may be added, is next to impossible with the Confederate and U.S. flags so similar in design and color." The reporter also described how the ceremony began with a fifteen-gun salute, the imposing mass of bayonets he saw glistening in the sunshine and the magnificent line of assembled troops, a half a mile long. After the Catholic chaplain of one of the Louisiana regiments gave a blessing, the new battle flags were distributed by the generals to the colonels of the regiments, the bands played and the soldiers marched in review. After the troops were dismissed, the reporter enjoyed "the feast of reason and the flow of soul" with a large party of officers at General Van Dorn's quarters.

The unofficial square battle flag adopted as a military necessity during the many ceremonies around Centreville in the autumn of 1861 went on to gain fame as the battle flag of General Lee's Confederate army of Northern Virginia. During the course of the bloody Civil War, the battle flag was never considered, by the army that made it famous or by the Confederate government, to be a substitute for the official Confederate national flag.

In May 1863, the troublesome first national Confederate flag, also known as "the Stars and Bars," was replaced with a second national flag.

Ironically, the flag now adopted was composed of the unofficial battle flag design imposed on the upper left quarter of a white field. In March 1865, a third national design was adopted. It added a broad bar of red on the fly end of the white field. Sometime in the early 1900s, the unofficial battle flag design evolved into the major symbol of the failed Confederacy. Today, the majority of America's populace believes the army of Northern Virginia's battle flag is the Confederate flag, something that it never was. Over time, the old battle flag pattern has acquired other symbolic and some sinister connotations. Loved by some and hated by others for what it purportedly represents to differing segments of a modern generation, at the time it was issued to the soldiers at Centreville, the flag was nothing more than an unofficial and practical way to help generals identify their combat units.

Before Virginia seceded, the Commonwealth of Virginia had no official flag. When Virginia's secession convention met in April 1861 and voted to leave the Union, it also passed an ordinance establishing a flag design virtually identical to the one currently in use. After the first battle of Manassas, General Johnston began urging the various Confederate states to provide state flags to their units. At the time, his action was seen as a partial remedy to the confusing national flag problem because state banners were easier to identify. In response to the general's request, Virginia went to great effort to make state flags available. Governor Letcher and many other dignitaries presented a host of state flags to the army's Virginia units at an imposing ceremony held at Centreville in October 1861. Drafted to military use at the summons of General Johnston, the Virginia flag became one of the battle flags carried into action by the troops. Few of the current residents of Virginia realize that the flag of the Commonwealth dates back only to the tumultuous year of 1861 and that it once saw hard service on the battlefields of Virginia, Maryland and Pennsylvania during a savage, nation-ripping war.

Although the troops that once stood in the massed formations around Centreville have all gone to their final rest, a surprising number of the battle flags they once carried have survived. The Museum of the Confederacy in Richmond has over five hundred flags in its extensive collection, one of the largest wartime flag collections in existence anywhere in the world. Included are eight of the flags originally issued at Centreville, five of which are the unit flags of the First, Eighth, Thirteenth, Eighteenth and Twenty-eighth Virginia Infantry. The three others once flew above the headquarters of Arnold Elzey, Edmund Kirby Smith and Gustavus Smith in the Rebel camps located along General Johnston's defensive

line. Two of the three original prototype flags made in the summer of 1861 are also in the collection. They were the first of the unofficial flags produced and were given to Generals Johnston and Van Dorn. The flag sewn by Ms. Hetty Cary and presented to General Johnston has been conserved and is currently on public display in the museum's exhibition titled: The Confederate Years.

Closer to home, the tattered banner of the Prince William Cavalry (Company A of the Fourth Virginia Cavalry) is on display at the Manassas City Museum. Carried in the early days of the Civil War, the flag, with its three alternating red-white-red stripes and blue field lettered with the words "Prince William Cavalry" and eleven five-pointed stars, is a good example of an early unit flag that was part of the flag confusion problem. The flag is also a bit unique in that the reverse side of the blue field is embossed with the seal of Virginia instead of the wording and stars. The Prince William Cavalry was a local outfit; some of the descendants of the unit's troopers still reside in the area.

The Centreville Press Fiasco

The military and the press often exist in an uneasy relationship, especially in time of war. It is a relationship replete with competing and conflicting interests, so the needs of the military and press are often at odds. During the Civil War, generals such as Lee, Johnston and Sherman believed newspapers created problems because they often published information useful to the enemy. Commanders on both sides avidly read the newspapers published in enemy territory because they were considered sources of useful military intelligence. Since the governments of United States and the Confederate States maintained the tradition of allowing the press to function relatively freely, the generals may have had a point.

There was no bigger story in the 1860s than the Civil War. For the journalists reporting military events, the job was fraught with danger, ethical conflicts, confusion and logistical problems. Striking a balance between telling the story completely and accurately and maintaining a degree of sensitivity to military security needs was a difficult task, one that often created difficulties for editors and generals alike.

When General Joseph E. Johnston made his headquarters at Centreville during the autumn of 1861, military security requirements and the rights of a free press collided head on. In December, the *Richmond Dispatch* published an article written by William Shepardson, a reporter

writing under the pen name of "Bohemian." In his article, Shepardson related how the army was busy erecting log houses for winter quarters and mentioned the names and location of the army units manning the fortifications around Centreville and Manassas, the placement of General Stuart's cavalry and the position of the army's artillery.

General Johnston was incensed when he read the article because about the only thing Shepardson got wrong was the name of the house Johnston was using as his personal quarters. Although the newspaper article cast his army in a favorable light, the general was enraged because the disposition of his troops had been made public. If Johnston had wanted the opposing Union commander to know precisely where and how the Confederates were hunkering down for the winter, he would have been hard pressed to provide better information than that found in the newspaper article. On December 30, 1861, the seething general sent a letter to Secretary of War Judah P. Benjamin in Richmond and strongly suggested Mr. Shepardson and the paper's editor be arrested and charged with the crime of revealing critical military information to the enemy. The angry Johnston did not believe the information had been published inadvertently; he thought Shepardson might be a Union spy, a smart one plying his ugly trade in the guise of a naïve newspaper reporter.

On January 5, 1862, the wily Confederate secretary of war wrote back to the general, informing Johnston that he too was "indignant at such an outrageous breech of duty by both the writer and the publisher." He went on to tell Johnston that the government could not punish the offenders under the existing laws. Benjamin also related how he had asked the Confederate Congress to pass legislation designed to "to protect the army and the country against the great evils resulting from such publications." The secretary then deftly shifted the responsibility for the affair back to Johnston and berated him for not controlling the movement of newspaper reporters in the area his army controlled. Benjamin bluntly told the general to arrest, confine and try by court-martial all dangerous and suspected persons caught prowling around the army's far-flung camps. Military law had to be applied, the secretary of war wrote, because the civilian courts would not confine those arrested by the government on the suspicion of being disloyal.

Naturally, General Johnston did not relish being reprimanded. He thought Secretary Benjamin's claim of being unable to control the press was nothing more than a thin excuse that allowed the Richmond authorities to avoid facing an unpopular political issue. After stewing

over his options, General Johnston acted. He ordered all newspaper correspondents barred from entering his army's camps.

Although General Johnston thought otherwise, the *Richmond Dispatch*, founded in 1850, was no den of Union spies or sympathizers. Edited by James Cowardin and John Hammersley, the paper had the largest circulation in the city, increasing from 18,000 to 30,000 during the course of the war. The *Dispatch* was politically nonpartisan, always patriotic and maintained a neutral editorial policy. William Shepardson appears to have been a good reporter who served the needs of the reading public. In this case, however, he and his editors appear to have displayed a wanton disregard for the security of Johnston's army. A little judicious editing of the specific locations and the names of the military units would have ensured that the army's troop dispositions would not reach enemy hands, if in fact they were not already known.

It is hard to believe that after nearly a year of war, newspaper writers and editors remained unaware of the damage that might be caused by the disclosure of troop positions. Perhaps the *Dispatch* published the story in the honest belief that the troop locations were already widely known to everyone, friend and foe alike. Was the long-ago debacle at Centreville caused by an intentional breech of security or a careless job of editing? Or was it just a quick-tempered general's overreaction to a newspaper story? Whatever the reason, it riveted the attention of a commanding general and a secretary of war back in the time when Centreville was a place of military importance.

The First Monuments

Northern Virginia held no fond memories for the Union forces stationed there; they had suffered two major defeats in the vicinity and their supply lines in the region were constantly under attack by Mosby's Rangers. However, it was in this shattered and melancholy region that the process of remembering those killed in battle began even before the conflict had ended. During the winter of 1864–65, Union soldiers stationed at Fairfax Court House constructed two brown sandstone monuments, each approximately twenty feet high, on the Manassas battlefields. The one located in the yard of the Henry House honors those killed in the first battle; the other located at the "Deep Cut" is in memory of those killed in the second battle. The inscriptions read: "In memory of the Patriots who fell at Bull Run, July 21, 1861" and "In memory of the Patriots who fell at Groveton, August 28, 29, 30, 1862." Although constructed during waning days of the war, the farsighted author of the inscriptions stated to an observer that the time would come when the term "Patriots" would apply to both the soldiers from the North and the South. He must have had a very clear vision of what the country was to become in the future.

The monuments must have been very impressive when built because they were almost the only new construction in a region that had been

thoroughly devastated by the war. For years afterwards, Union and Confederate veterans and their families traveled through Centreville over the same roads they had marched on in wartime to visit the monument sites. Those simple sandstone shafts probably had the same emotional significance for the Civil War veterans as the Vietnam memorial has to a later generation. As the years passed, the surviving battle participants became fewer and the living connection with military events in Northern Virginia slowly faded. The importance of the monuments to individuals probably ended when the last veteran of the battles went to his grave. On March 12, 1952, James A. Hard died at Rochester, New York, at the age of 111 years and 8 months. He was the last combat soldier of the Civil War who had participated in both Manassas battles, having served as a private in a New York regiment. His death erased the last living connection to the events recorded on the monuments.

THE RESIGNATION OF STONEWALL JACKSON

During the Civil War, General Thomas J. (Stonewall) Jackson became one of the Confederacy's most celebrated generals. Beginning with the first battle of Manassas in July 1861, and later as an army corps commander under Robert E. Lee, Jackson made military history. His enduring fame has overshadowed the fact that a disgusted Jackson almost ended his career before it began when he resigned from the army during the winter of 1861–62. Jackson was with Johnston's army in Northern Virginia during the autumn of 1861. The Confederate government in Richmond and the senior army commanders at the Centreville headquarters had by then developed an extremely testy relationship over supply matters and war policy. The generals were, to say the least, not a group of happy campers.

In November, Jackson was assigned to command the Valley District with his headquarters at Winchester. He was not there long before a disagreement arose with Confederate Secretary of War Benjamin over the disposition of some of Jackson's troops. When Benjamin sent him an order that Jackson disagreed with because it undermined his authority, Jackson complied with it and sent in his resignation. Following proper military channels, the document went first to General Johnston at Centreville and then on to Richmond. It reads as follows:

Headquarters Valley District,
Winchester, Va., January 31, 1862

Hon. J. P. Benjamin, Secretary of War:
Sir: Your order requiring me to direct General Loring to return with his command to Winchester immediately has been received and promptly complied with.

With such interference in my command I cannot expect to be of much service in the field, and accordingly respectfully request to be ordered to report for duty to the superintendent of the Virginia Military Institute at Lexington, as has been done in the case of other professors. Should this application not be granted, I respectfully request that the President will accept my resignation from the Army.

I am sir, very respectfully, your obedient servant,
T.J. Jackson,
Major General, P.A.C.S.

(Endorsement) Headquarters,
Centreville, February 7, 1862
Respectfully forwarded, with great regret. I don't know how the loss of this officer can be supplied. General officers are much wanted in this department.

J.E. Johnston,
General

The loss of Jackson's services would be a serious blow to the Confederate war effort and a firestorm of protest erupted. President Davis refused to accept the resignation, the governor of Virginia, General Johnston and a host of Jackson's other friends all got into the act, and Jackson was persuaded to withdraw it. A few months later, he made military history when he swept the Shenandoah Valley clear of Union troops in his famous campaign of 1862. The fact that Stonewall Jackson was so fed up with the meddling in his departmental affairs that he was willing to resign and go back to teaching students at the Virginia Military Institute was quickly and conveniently forgotten by the Confederate authorities and the general public in the South.

THE PHOTOGRAPHER

In early March 1862, Union scouts began to pick up indications of a hasty and massive Confederate troop movement. On March 11, Union Major General George B. McClellan personally inspected the Rebel positions around Centreville and confirmed that Joseph Johnston's army had abandoned its fortification line. As Union troops occupied the empty Confederate positions, curious civilians and newspaper reporters rushed out of Washington to see the fearsome Rebel defenses and the abandoned winter quarters firsthand.

Among them was George N. Barnard, a photographer. As one of the pioneers in the new field of photography, he had opened a daguerreotype studio in Oswego, New York, and established a national reputation for the quality of his portraits. He later went to work for Matthew Brady's studio in New York City and eventually became one of the twenty-two photographers Brady sent into the field to record the Civil War. Along with Timothy O'Sullivan, John Reekie and Alexander Gardner, Barnard photo-documented the war's early stages for Brady's organization. It was at a time when Brady took credit for all the photographs produced by his employees. Since Barnard worked in Northern Virginia in 1861–62, many of the

photos taken in the Centreville and Manassas region and attributed to Brady were actually taken by George Barnard.

Later in the war after leaving Brady's firm, Barnard became the photographer for General William T. Sherman and accompanied his army on its famous march through Georgia. Barnard's 1866 publication titled *Photographic Views of Sherman's Campaign* is considered to be a masterwork of early American photo publishing. It was also extremely expensive, selling for one hundred dollars a copy in its early editions.

Barnard was working in Chicago when the great fire destroyed his studio in October 1871. He quickly located new supplies and photographed the city's smoking ruins to document the disaster. He then moved to the South and operated a studio in Charleston, South Carolina, from 1873 to 1880. After returning to the North, he worked as the spokesman for the new line of photographic supplies being manufactured by the inventor George Eastman.

Although he traveled with the armies and photographed the destruction of war, George Barnard was a gentle and modest man. He spent his last years residing at his son-in-law's farm, taking pictures of schoolchildren, friends and neighbors. He died in 1902 at the age of eighty-two and was buried in a quiet country cemetery in Cedarvale, New York. In 1964, the Onondaga County Historical Society placed a marker on his grave commemorating his role in the development of early photography. Today, originals of Barnard's Civil War work command prices ranging from $800 to $4,000, depending on the subject matter. His renowned photographs hang in the collections of many museums, including the Getty. The man who took pictures in Centreville in March 1862 deserves to be remembered for his skill in using the cumbersome cameras of his time. Not only did he leave us a photographic record of the Civil War, he helped make photography what it is today.

About the Author

Karl Reiner was educated at the Ohio State University and the Garvin School of International Management. An Air Force officer and veteran of the Vietnam War, he went on to a distinguished government career in Washington, D.C., where he worked in international economic affairs. He lived in Fairfax County, Virginia, from 1973 until 2005. While there, his interest in local history led to a hobby of writing historical articles that appeared in Virginia publications. Now retired, he resides with his wife Martha in Tucson, Arizona.